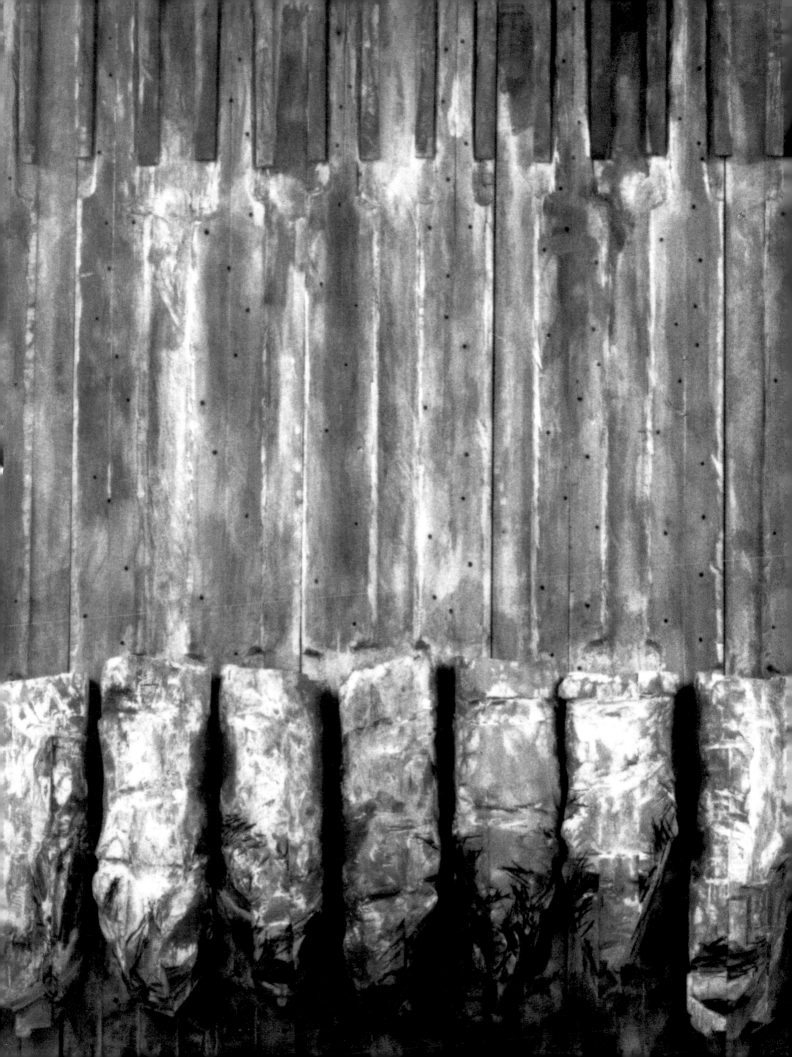

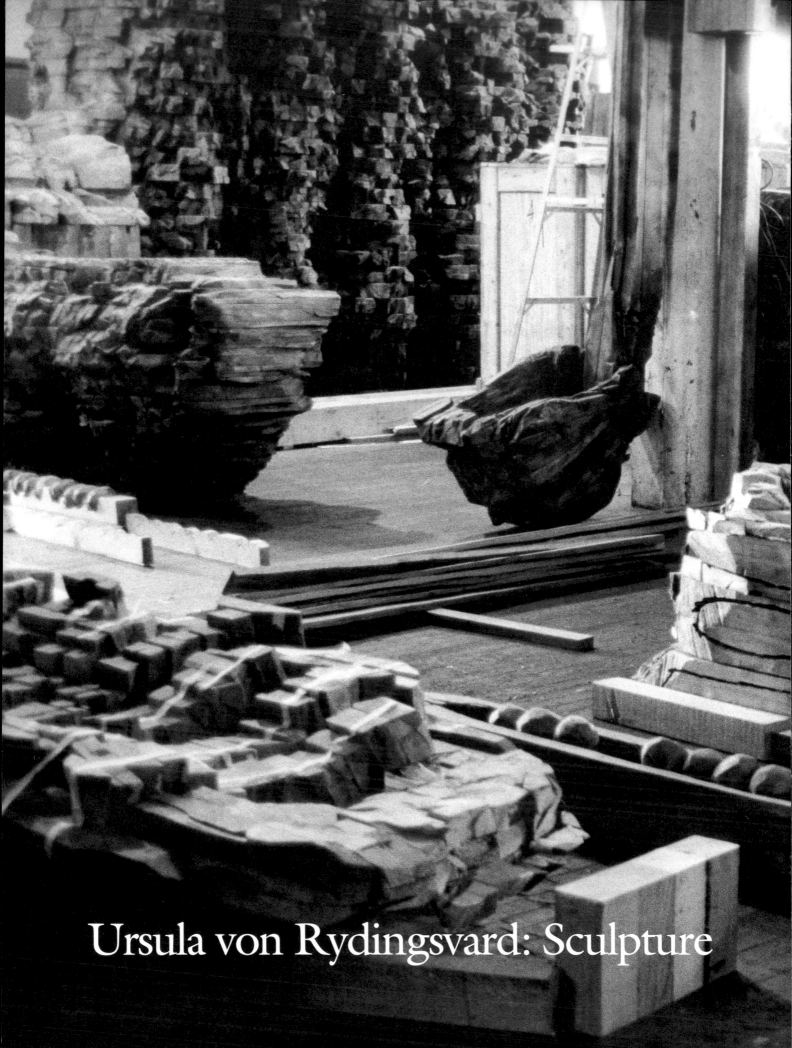

Ursula von Rydingsvard: Sculpture

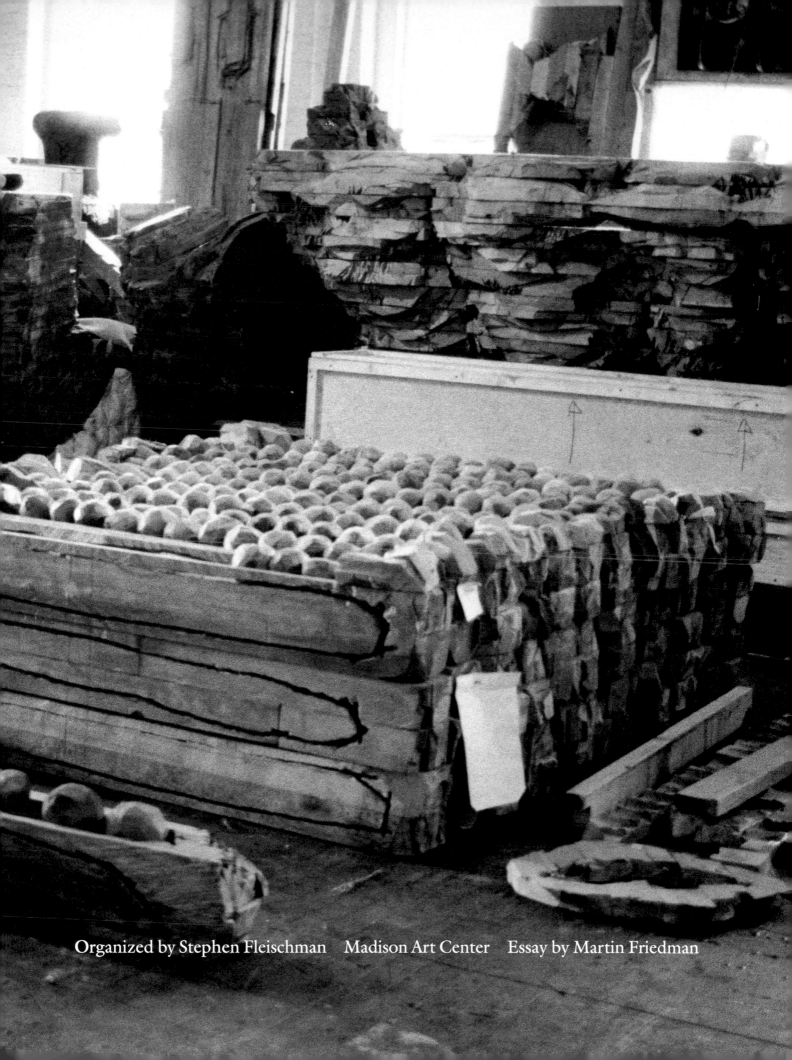
Organized by Stephen Fleischman Madison Art Center Essay by Martin Friedman

Ursula von Rydingsvard: Sculpture was organized by the Madison Art Center. Major funding has been provided by The Andy Warhol Foundation for the Visual Arts, Inc.; additional support has been provided by a grant from the Dane County Cultural Affairs Commission, with additional funding from the Madison Community Foundation; The Art League of the Madison Art Center; the Exhibition Initiative Fund; the Madison Art Center's 1997–1998 Sustaining Benefactors; and a grant from the Wisconsin Arts Board with funds from the State of Wisconsin.

Travel Schedule

March 1 – May 10, 1998
Madison Art Center, Madison, Wisconsin

July 18 – October 4, 1998
Hood Museum of Art, Dartmouth College, Hanover, New Hampshire

December 5, 1998 – January 31, 1999
Chicago Cultural Center, Chicago, Illinois

March 24 – June 6, 1999
The Contemporary Museum, Honolulu, Hawaii

Library of Congress Cataloging-in-Publication Data

Von Rydingsvard, Ursula, 1942–
 Ursula von Rydingsvard : sculpture / organized by Stephen Fleischman ; essay by Martin Friedman.
 p. cm.
 Catalog of an exhibition held at the Madison Art Center, Madison, Wis. and three other institutions between March 1, 1998 and June 6, 1999.
 Includes bibliographical references.
 ISBN 0-913883-25-5 (hc)
 1. Von Rydingsvard, Ursula, 1942– —Exhibitions.
I. Fleischman, Stephen, 1954– . II. Friedman, Martin.
III. Madison Art Center. IV. Title.
NB237.V58A4 1998
730'.92—dc21 98-11745
 CIP

Printed in the United States of America
Edition of 1500
All rights reserved

A braille version of this catalogue is available upon request. Please contact the Madison Art Center Education Department.

Editor
Mary Maher, Madison, Wisconsin

Design
Glenn Suokko, Woodstock, Vermont

Printing
The Stinehour Press, Lunenburg, Vermont

Photography
David Allison—p. 5, 6, 10, 19, 30, 34, 35, 38, 39, 41, 42, 44, 48, 64, jacket
Ben Barnhart—p. 23, 26, 45
Vincent Dente—p. 46
Glenn Halvorson—p. 40
Larry Lame—p. 36–37
Marbeth—p. 1, 28
Jennifer Reiss—p. 17
Ursula von Rydingsvard—p. 33
Jo Ann Weinrib—p. 2–3, 57
Zonder Titel—p. 21, 52

Page 1: *Zakopane* (detail), 1987

Contents

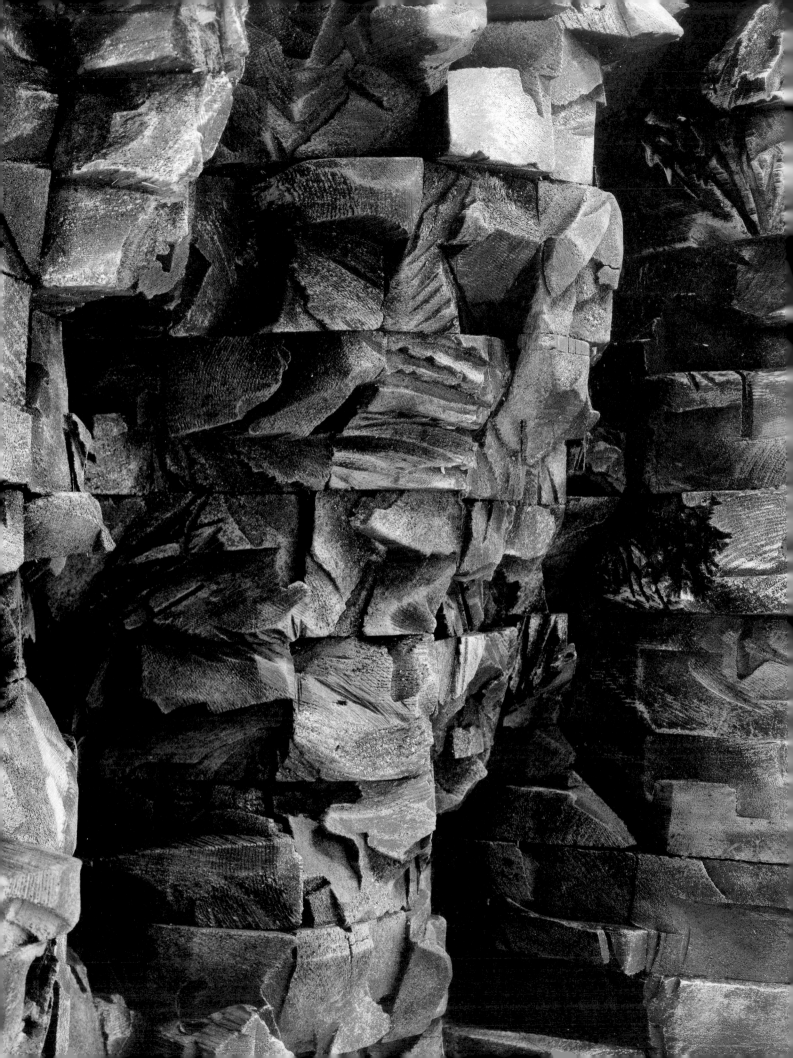

Introduction

I was introduced to Ursula von Rydingsvard's sculpture in the spring of 1990, when her large-scale work, *Three Bowls,* was installed in the Minneapolis Sculpture Garden across the street from the Walker Art Center. I remember circling the sculpture's bold vertical forms, marveling at its craggy exterior and feeling slightly intoxicated by the sweet smell of cedar. The detailed surfaces, its reference to bowls and other familiar objects, made the sculpture feel intimate despite its substantial height and width. In 1994, I saw another von Rydingsvard sculpture, this one created specifically for the landmark exhibition *Visions of America: Landscape as Metaphor in the Late Twentieth Century,* organized by the Denver Art Museum and the Columbus Museum of Art, and curated by Martin Friedman, author of the essay in this publication. This commission, installed on the rooftop of the Denver Art Museum, consisted of thirteen horizontal elements that harmonized with the dramatic vista of the Rocky Mountains. Since then, I have followed the evolution of von Rydingsvard's career, as she continues to develop an important body of outdoor and interior work. It is an honor for the Madison Art Center to organize and present the first traveling survey of indoor sculpture by this significant artist. *Ursula von Rydingsvard: Sculpture* provides an important opportunity to assess von Rydingsvard's oeuvre of the past two decades and, at the same time, extend the Art Center's tradition of producing exhibitions of work by key figures in post-World War II American art.

Von Rydingsvard's sculpture isn't easy to categorize. It has qualities that sound contradictory. Her work is abstract, yet highly evocative; based

Nine Cones (detail), 1990
Cedar and graphite
Collection Emily Fisher
Landau, New York

7

on geometry, but irregular in form and surface; large-scale, yet intimate in effect; it is simultaneously primitive and elegant. Her sculpture is informed by influences as disparate as Abstract Expressionism and Minimalism. Even her working method includes the polar extremes of building (the layering of cedar boards) and carving (she employs hand and power tools to shape and define her sculpture).

In a sense, Ursula von Rydingsvard's sculpture serves as a bridge between many movements that have shaped twentieth-century art. Her approach is pragmatic. Surveying the forms and techniques associated with modern and contemporary sculpture, she reinvents those that fit her expressive purposes. Her sculpture serves as a connector between abstraction and the world of real things, like tableware, farm implements and other domestic objects subtly referenced in her work. They resonate with a sense of history and human life. Despite her sculpture's complex origins, they are imbued with a cohesive, refreshingly direct quality. Von Rydingsvard employs repetitive processes, layering and removing material like the natural forces of erosion. Yet this methodical approach allows for a high degree of improvisation. Her sculpture seems to take form in a subconscious state, where the artist's mind makes connections based on the shapes that appear before her. Ultimately, von Rydingsvard's work coalesces around the strong vision, ideas and personal experiences that have directed her art for decades and anointed it with a distinct and original character.

It has been a pleasure to collaborate with Ursula von Rydingsvard on every aspect of this project. In addition to her creative contributions, she willingly answered the many questions posed to her by the Madison Art Center's staff. Her warmth and graciousness made organizing the exhibition and producing this catalogue an extremely rewarding experience.

My profound thanks also go to von Rydingsvard's longtime assistant, Bart Karski. In addition to his invaluable work as Head of Studio, he provided the Art Center with important information for this catalogue and facilitated the shipment of sculptures from von Rydingsvard's Brooklyn studio. Mark Shunney and Christopher Romer also provided valuable assistance in the artist's studio. Mary Sabbatino, Director, and Cécile Panzieri, Associate Director, of Galerie Lelong, New York, greatly assisted the Art Center in coordinating many facets of this project.

Several generous funders helped make *Ursula von Rydingsvard: Sculpture* possible. Major funding for this project comes from The Andy Warhol Foundation for the Visual Arts, Inc. Additional support was pro-

vided by a grant from the Dane County Cultural Affairs Commission, with additional funding from the Madison Community Foundation; The Art League of the Madison Art Center; the Exhibition Initiative Fund; the Madison Art Center's 1997–1998 Sustaining Benefactors; and a grant from the Wisconsin Arts Board with funds from the State of Wisconsin.

Martin Friedman, Director Emeritus of the Walker Art Center, authored a thoughtful essay for this catalogue that clearly places von Rydingsvard's sculpture in context, and contributes much to the existing literature on the artist. Glenn Suokko designed an elegant publication, the text of which was carefully edited by Mary Maher. Photography for this publication was provided by David Allison; Ben Barnhart; Vincent Dente; Glenn Halvorson; Larry Lame; Marbeth; Jennifer Reiss; Ursula von Rydingsvard; Jo Ann Weinrib; and Zonder Titel; individual photo credits are cited on page 4.

The exhibition would not have been possible without the generous lenders who agreed to make works available. I am grateful to Galerie Lelong, New York; Vera List; Ursula von Rydingsvard; and the Walker Art Center, Minneapolis.

After its premiere at the Madison Art Center, *Ursula von Rydingsvard: Sculpture* travels to three important venues. It has been a pleasure to work with Timothy Rub, Director of the Hood Museum of Art at Dartmouth College in Hanover, New Hampshire; Gregory Knight, Director of Visual Arts and Chief Curator at the Chicago Cultural Center; and James Jensen, Associate Director/Chief Curator of The Contemporary Museum in Honolulu. This broad geographic tour ensures that large audiences will enjoy the exhibition.

I wish to thank the Madison Art Center's Board of Trustees for their support and unwavering enthusiasm. It is a pleasure to acknowledge the contributions of the museum's entire staff, several of whom deserve special recognition: Ina Dick, Assistant to the Director; Ellen Efsic, Director of Development and Community Relations; Sheri Castelnuovo, Curator of Education; Toby Kamps, former Curator of Exhibitions; Marilyn Sohi, Registrar; Lisa Lardner, Assistant Registrar; David Lantz, Publicist; and Technical Services Supervisor Mark Verstegen and his entire exhibition crew.

Stephen Fleischman
Director
Madison Art Center

9

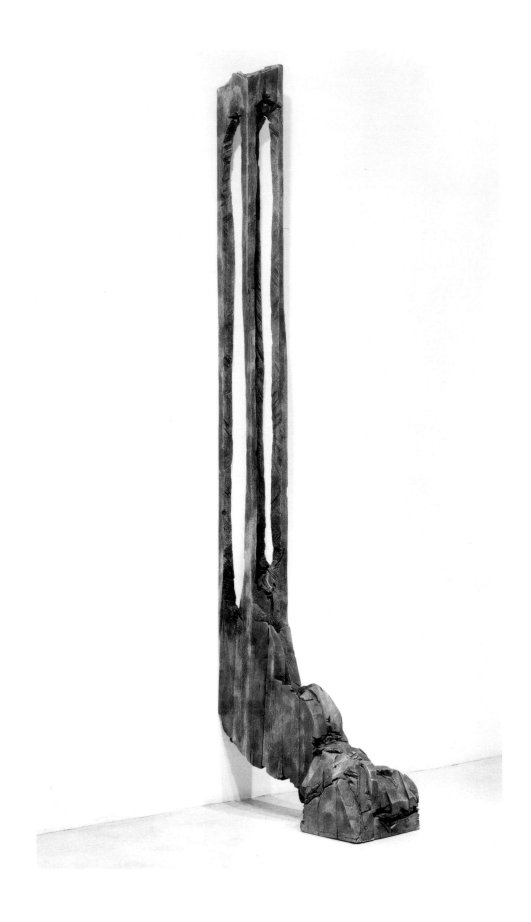

Von Rydingsvard: Mining the Unconscious

Martin Friedman

The massive wooden sculptures laboriously hauled down the steep stairs or craned out the window of Ursula von Rydingsvard's second-floor studio, near the Manhattan Bridge in Brooklyn's Williamsburg section, are a remarkable fusion of raw, elemental forms and highly expressive content. In the sprawling studio space she has occupied since 1984, von Rydingsvard and her longtime assistant, Polish-born Bart Karski, can be found energetically at work on large-scale sculptures, often several at once. Wearing strapped-on, muzzle-shaped respirators as protection against a thick haze of sawdust and glue fumes, they are a spectral pair. For all her slender elegance, von Rydingsvard approaches making sculpture with creative ferocity—hauling, stacking, sawing, and gluing huge cedar planks to form her complex pieces, then vigorously slicing into and abrading their surfaces that she then darkens with a mixture of oil and graphite. Serenely indifferent to all this activity, peacefully asleep in his cage under a battered worktable, is Miś (Polish for stuffed bear and pronounced Meesh), her enormous but gentle Bernese Mountain dog who occupies the back of a station wagon during von Rydingsvard's daily back-and-forth runs to the studio.

What is apparent immediately in a von Rydingsvard sculpture is how it abounds with allusions to everyday objects and the timeless forms and processes of nature. Moreover, a strong sense of human presence suffuses her work. Many forms are raw transcriptions of tools and other hand-held

Berek, 1994
Cedar and graphite
107 x 14 x 32 inches
Collection of Whitney
Museum of American Art,
New York
Gift of Linda and Ronald
F. Daitz and an anonymous
donor, by exchange

11

objects that, despite their gargantuan scale, seem battered and worn, as though they have received extensive use. Others radiate decidedly anatomical associations. Flickering through many of von Rydingsvard's abstract sculptures are phantom images of gaunt torsos, extended limbs, knee joints, widely opened mouths, straining tendons, bulky musculature. There also is a suggestion of forceful physical movement, like bending, stretching, and twisting. Such insistent impressions emanate from even the most abstract of her sculpture. For the observer who communes with these shadowy volumes, these provocative visual clues constantly intensify and mutate.

Since, in a von Rydingsvard sculpture, nothing is ever what it seems to be—at least not for long—widely differing readings of its content are equally valid. The 1994 sculpture *Berek*, for example, encourages many interpretations. Its elongated, vertical mass of tightly fitted cedar lengths evokes a seated figure, its back to the wall and clasped hands raised high over its head; but it could just as well be four streams of water cascading to the ground. In this art of ambiguity and contradiction, heavy volumes that appear rooted to the floor can become depthless atmospheric masses. Distinctions between natural and man-made forms are virtually nonexistent in this primal iconography where basic geometry and organic forms so readily fuse.

Von Rydingsvard's persona, like her sculptures, with their elusive, everchanging imagery, is multilayered and not easily read. In her perceptions and attitudes about art and life, she is very much a contemporary New Yorker. At the same time, much of her outlook has been shaped by complex, often troubling memories of her childhood in Europe. Given to black attire, whether working in the studio or outside of it, von Rydingsvard is reserved in manner and soft-spoken. She was born Ursula Karoliszyn in 1942 in Germany, the child of a Polish mother and Ukrainian father. She was the fifth of seven children in a devout Catholic family. Like many other internees at the time, the Karoliszyns were part of the massive upheaval of civilian populations in the Ukraine during World War II. They had been sent to Deensen in north central Germany where her father labored on a collective farm. After Germany's defeat in 1945, the family was shunted from one refugee camp to another. Along with thousands of dispossessed

persons, they then waited anxiously for permission to come to the United States. In some camps they lived in sparsely furnished wooden buildings that had been American army barracks. Other living quarters, von Rydingsvard remembers with dismay, had served as housing for German concentration camps during the war. "They kept moving us," she recalls. "I'm not sure there was even a rationale. When a camp became empty, or whenever spaces the Germans weren't using suddenly became available, we were moved there. It's not that we chose to go there. We were given orders and within eight hours had to go."

For eight years, the stateless Karoliszyns migrated from one set of impersonal surroundings to another, none of which could remotely be considered *home*. The barracks' bleak interiors varied little: bare walls and a few essentials like steel-frame beds, chairs, tables, and a stove. During their migrations they acquired basic cooking and eating utensils, some left by departed GIs. Though they had minimal possessions, the family managed to salvage a few household items from the Ukraine. Of these, von Rydingsvard remembers a wooden chest, some heavy, goose-feather quilts under which several children could sleep together, and an icon—actually a framed watercolor—that depicted Christ on the Cross. This was dutifully hung in each temporary abode and made the object of daily devotions. But that painted effigy could, on occasion, become the focus of her father's frustration with their harsh existence. She vividly remembers how, in an uncontrollable fit of anger, he flung the contents of a coffee mug at this sacred object, causing its painted surface to streak.

Most of the eating utensils provided at the camps were stamped with the initials "USA" and, of these, the spoon held special significance for von Rydingsvard. A particularly vivid childhood memory she has is of a spoon suspended from a string her mother tied around her neck so she would not lose it. She not only ate with it but wore it to the Polish kindergarten in a nearby barracks and while playing outdoors. Given its constancy in her childhood, it's no surprise the spoon has been a recurring form in her sculpture and, at times, mutated into other well-remembered objects from those bleak days, like spades, shovels, and soup ladles. However much such objects inhabit her memory, von Rydingsvard says she does not seek

to recreate them as sculptures. "Never, ever, do I recall being in my studio and directly connecting a memory to the piece I'm working on."

Despite their vicissitudes, the Karoliszyn family managed to remain intact during their long years in Germany. Finally allowed to emigrate to the United States in 1950, thanks to sponsorship by an international Catholic organization that assisted Polish émigré families, they settled a year later in Plainville, Connecticut, a working-class community where, at first, they were regarded as exotic curiosities. The closest town with a large number of Polish immigrants was New Britain, a few miles away. In Plainville, her parents soon found various low-paying jobs, including factory work, digging and hauling tree stumps, and after-hours cleaning of a restaurant where, eventually, her mother worked as a baker. In Plainville, the tensions of labor camp life were replaced by new ones as the anxious immigrants sought to adjust to a strange new land. Young Ursula managed the household, cooking, cleaning, and caring for younger brothers and sisters, while attending public school. There was little time for artistic or, for that matter, any other extra-curricular pursuits. Besides, such activities were deemed frivolous and derided as a waste of time, she recalls, by her largely absent parents. She had no thoughts then of becoming an artist, but rather of being accepted as a normal American teenager by her school friends.

After graduating from high school in 1960, she enrolled at the University of New Hampshire in Durham where she took her first drawing and painting courses. Why she selected that school, she muses, is still unclear except it was recommended by a high-school friend who already had enrolled. For von Rydingsvard, this was the beginning of an erratic, often-interrupted cycle of studies that would eventually take her from one coast to the other, with a stop-off in Florida. From 1962 to 1965, she attended the University of Miami and, during those years, married Milton von Rydingsvard, a Plainville native, then a student at the University's medical school. In 1969, they moved to Oakland, California, where he interned at the Kaiser Foundation Hospital, followed by a brief residency at Berkeley Memorial Hospital. Eager to pursue her own studies, von Rydingsvard took a few art education classes at the University of California, Berkeley, but this proved to be an unhappy experience. She found herself increas-

Untitled (cones), 1976

14

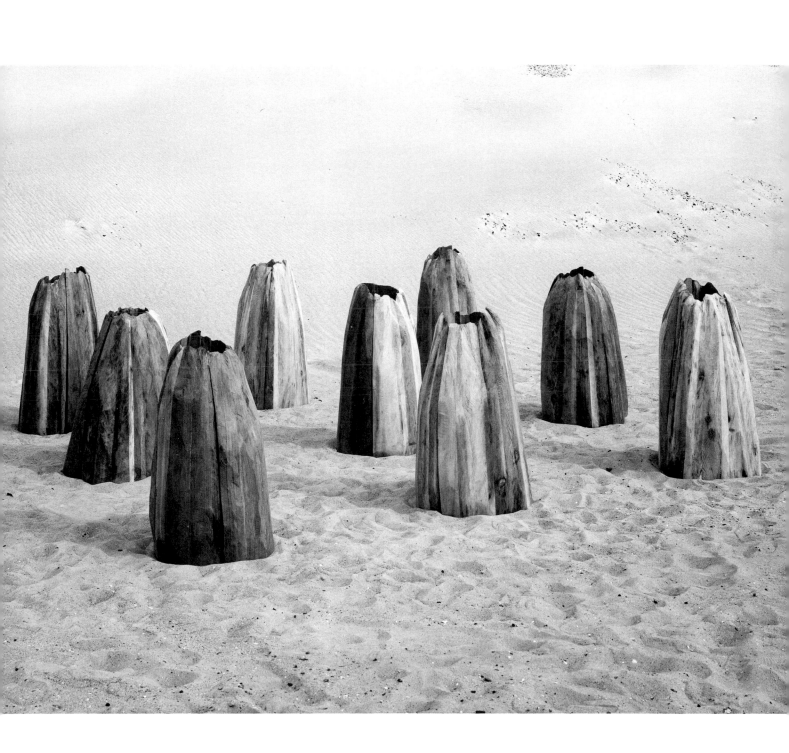

ingly disaffected by educational methodology courses and finally determined her real interest was studio art. During their California years a daughter, Ursula Ann, was born.

Von Rydingsvard and her husband separated in 1971 and she moved to New Britain with her young daughter. The following year she decided to take summer art courses at the New School for Social Research in New York City. Two years later, by now intent on a career as an artist, she moved to New York to enroll in a masters program in fine arts at Columbia University, where she also audited lectures by Meyer Schapiro, the widely revered art historian who was a champion of the new American modernism. Among her studio instructors were the sculptors George Sugarman and Ronald Bladen, two assertive artistic personalities whose approaches to three-dimensional form could not have been more disparate. Sugarman was known for massive, elegantly balanced Légeresque wood constructions whose surfaces he painted in vivid hues. By contrast, the purist Bladen used Minimalism's planar vocabulary in dynamic configurations fabricated of welded steel. After earning her degree in 1975, von Rydingsvard found a studio in SoHo where she began making carved wood pieces. Among the first was the 1976 *Untitled (cones)*, an impressive cluster of tall, hollow shapes with tapered sides carved in deep, undulating furrows. Even in such early sculptures, von Rydingsvard's stylistic direction was apparent. Her idiom was organic abstraction, a highly energized synthesis of naturalistic and geometric forms.

The sources of von Rydingsvard's imagery are diverse and widely separated by time and place. With respect to historical art, her preference has always been for strong elemental forms that embody powerful mystical forces, as so vividly evidenced in African tribal sculpture, archaic Greek marble temple figures, and the vigorously carved stone saints on early Christian church facades. Of early modernist influences, the most stirring have been Giacometti's spiritualized heads and figures, within whose indeterminate bronze surfaces she perceives shadowy, dreamlike landscapes. Like others of her generation, von Rydingsvard was responsive to the Abstract Expressionist artists' penchant for bold, gestural strokes and the way they incorporated the evidence, however messy or tentative, of a painting's

Song of a Saint (Saint Eulalia), 1979, cedar 12 x 330 x 160 feet Installation at Artpark, Lewiston, New York, 1979. Destroyed.

16

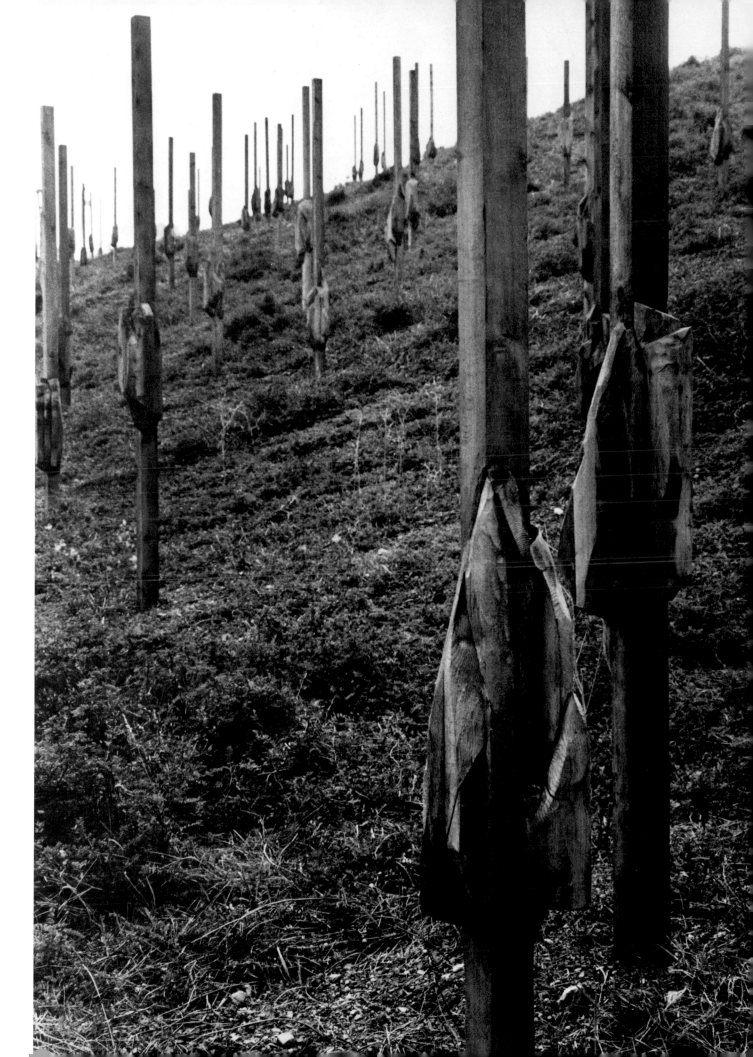

making—the brush marks and erasures—in the final work. As to sculpture, from early on she was drawn to the Minimalists' focus on irreducible, unitary shapes and their use of these as repeated elements in floor pieces and on outdoor sites.

Especially inspirational during the 1970s were ambitious projects by the earthworks artists, among them Robert Smithson and Michael Heizer. In fact, the enormous scale and vitality of these forceful interventions in the landscape encouraged von Rydingsvard to make several huge outdoor sculptures. One of the most affecting was the 1979 *Song of a Saint (Saint Eulalia)*, commissioned as a temporary work by the then-thriving Artpark in Lewiston, New York. This richly expressionistic, space-filling configuration was a veritable forest of twelve-foot-high cedar beams. Attached to these verticals at varying heights was a proliferation of carved swollen pods, like exotic growths on stark tree trunks. But among contemporary artists she most admired, none was more influential than Eva Hesse. Like the Minimalists, Hesse used industrial and synthetic materials, but there all similarity ended, for in her hands, soft plastic tubing, sheets of transparent fiberglass, and bits of aluminum screening took on a beguiling new identity as components of sensuous assemblages redolent with anatomical associations.

By the end of the 1970s, von Rydingsvard was well on her way to evolving her own visual syntax. She had arrived at a decidedly individualistic way of working with wood and, more important, a personal stylistic approach that was a rich synthesis of form and intense emotional force. Soon, her sculpture was attracting positive response from critics, collectors, and fellow artists. In 1982, she was hired to teach sculpture at Yale University. There she met Paul Greengard, then a neuroscientist on the school's faculty of medicine, and in 1985 they were married.

When pressed to discuss the sources of her sculptures, von Rydingsvard does so in a hesitant, understated fashion. Her comments about specific works tend to be elliptical—often interspersed with tentative references to remembered events, places, and experiences. It's far easier for her to describe the actual process of making a work than to illuminate its meaning for the listener. A question about the genesis of a piece inevitably elicits a

Doolin, Doolin, 1995–1997
Cedar and graphite
83 x 212 x 77 inches
Private collection

18

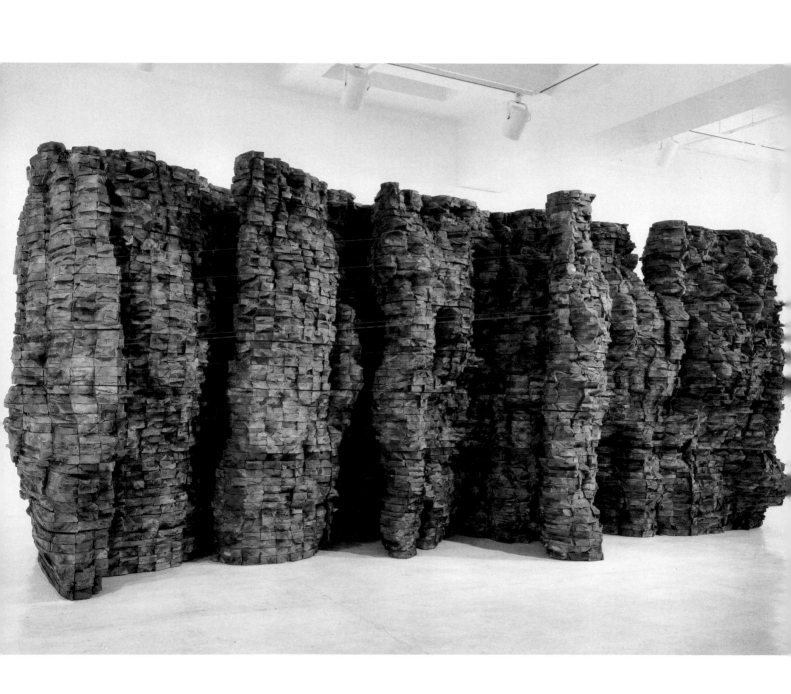

typical von Rydingsvard free-association response. In meditative fashion, she might trace a sculpture's beginnings to a remembered childhood game, a Polish folk song, or the memory of a dense forest or mountain slope. In these accounts, remembered objects and experiences fuse and a tantalizing ambiguity, intended or not, is the result of these fascinating free-form disquisitions.

During fabrication, virtually any von Rydingsvard sculpture is in a constant process of modification and often undergoes radical changes of form, size, and relationship to the floor or wall. What began life as a floor piece may ultimately end up as a wall relief with only a few original components still intact. Sometimes, as in *Doolin, Doolin,* a massive undulating wall made for her 1997 Galerie Lelong exhibition in New York, the piece begins as a tentative effort to come to terms with her own history. This sculpture started with a few laboriously written words traced from a letter received from her mother, Kunegunda, who died in 1996. By replicating this fragment of script in large scale on her studio floor, von Rydingsvard arrived not only at the sculpture's "footprint" but, in some intangible way, connected it with the memory of her mother. In tracing the words, she was implicitly indulging in a form of automatic writing through which she communed with her past.

While von Rydingsvard has always eschewed elegant contour and finished surfaces in favor of a primal directness, the assertive, space-commanding presence she creates belies the intuitive trial-and-error way they come into existence. She makes no preliminary drawings for these. The fact is, for all the considerable craftsmanship involved, her richly expressive forms are arrived at intuitively. She constantly tests wood-shaping techniques to achieve a desired configuration, often making part of an envisaged piece in small scale to see how it works.

During a few recent visits to von Rydingsvard's studio, I saw several thin, boat-like containers on the floor filled with carved wooden balls that looked like parallel rows of giant pea pods. As we walked around them, I wondered aloud whether these might end up as a finished piece; from her dubious expression, it was clear the jury was still out. The fact is, usually her studio contains several works, some of considerable size, that have not

Krasavica (detail)
1992–1993

20

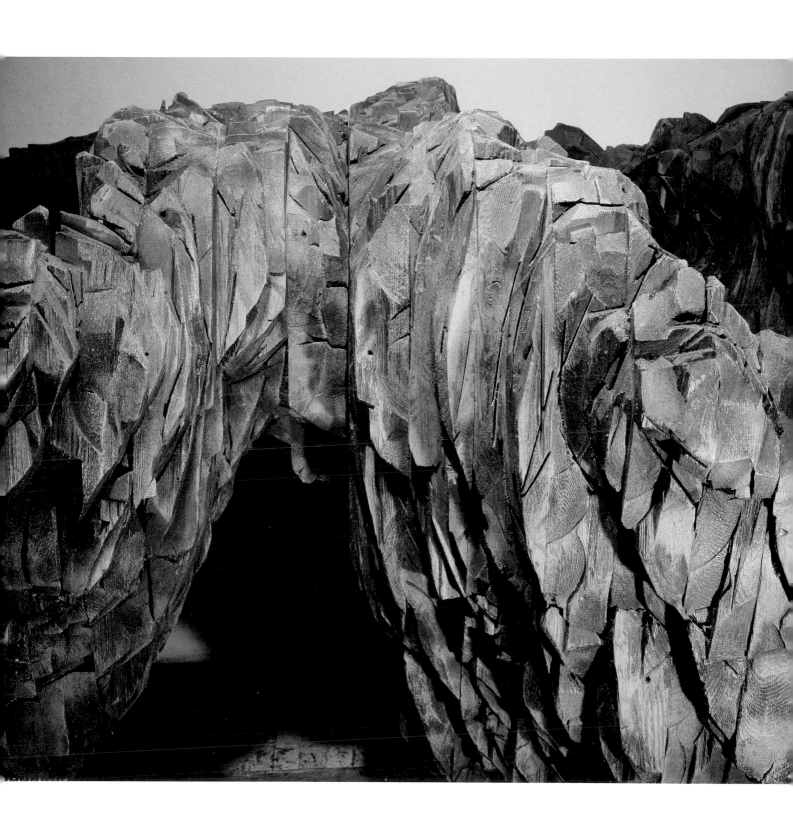

progressed beyond this initial stage. However, even though set aside for a while, some of these false starts probably will be incorporated into other sculptures whose overall forms may have little relationship to the original effort.

The most accessible of von Rydingsvard's sculptures are those based on recognizable objects, some that relate to her family's enforced stay in German detention camps. Transmuting the memory of these objects, into a body of highly expressive sculptures, is the mystery that lies at the heart of her work. And while some of these generic shapes recall her troubled early history, they also are her touchstones to exploring a wondrous world well beyond mundane reality.

Of these ubiquitous objects, the weighty, uneven-surfaced wooden bowl has long been a recurring von Rydingsvard theme—perhaps her most important one. Despite its overtly functional form, she says, a bowl can express a vast range of meaning: "I feel it's possible to make something very utilitarian, yet have it be very moving," she says, adding, "I use images of utilitarian objects as a springboard for much of what I do." Her wooden containers, which vary from low, shallow dishes to towering cylinders, lend themselves to many readings. For von Rydingsvard, the bowl is a universal, all-embracing form: "...a world, a vessel of emotions, a nurturing mother." But, she says, it also can embody darker feelings and, perhaps, be perceived as a devouring mouth.

Another point of departure for the bowl form in her art is lyrical and less symbol-freighted, as exemplified by the 1992–1993 sculpture titled *Krasavica*. Von Rydingsvard says the last thing she had in mind was making a five-part bowl piece. Rather, its inspiration, of all things, was a pair of cast-iron Japanese stirrups seen in a display case at The Metropolitan Museum of Art. Though little interested in samurai paraphernalia, she was enthralled by their elemental construction, each stirrup consisting of an elegantly curved metal enclosure simply attached to a flat sole to accommodate the warrior's foot.

Determined to make a sculpture based on the rounded stirrup shape, von Rydingsvard began work on a floor piece. Over a flat wooden "sole," she formed a rounded hollow and decided to connect this form to four

Untitled (Three Baskets), 1995

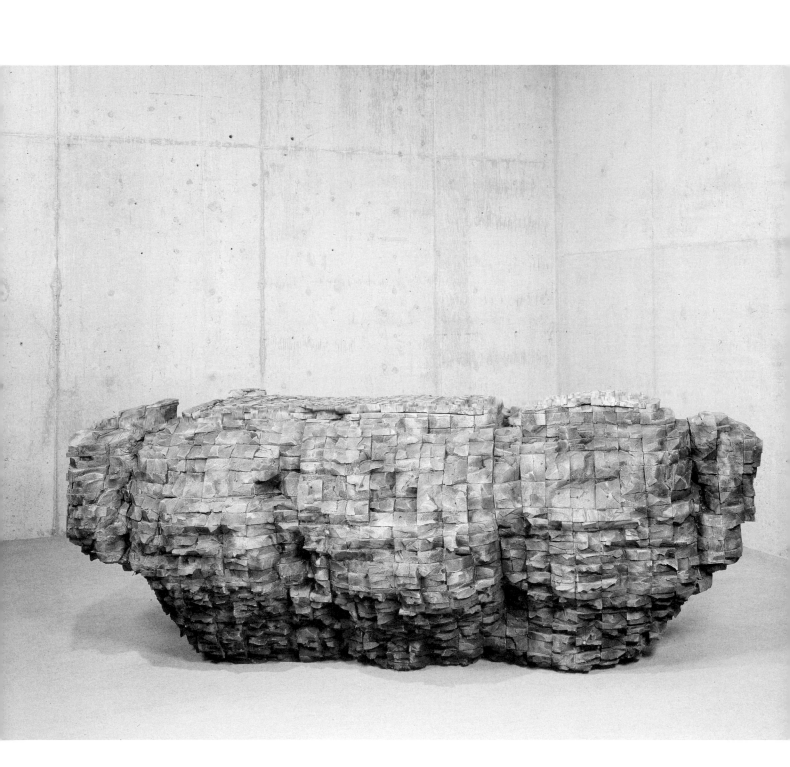

similarly shaped enclosures. As in other works, the original idea somehow got away from her and began to mutate. Soon, the floor piece evolved into a five-part wall sculpture, a sequence of soft-edged, waist-high containers. If we let our minds run a bit, von Rydingsvard suggests, these shapes could be a line of dancers or at least of swirling skirts. Despite their solid material, the deeply carved surface of each joined vessel seems oddly malleable, and each has a spout-like dip in front. For all its lyricism, *Krasavica* exudes a whiff of von Rydingsvard's occasionally dark, anarchic humor. "If any thoughts went through my head in making that piece, it's this" she recalls, "I wanted to make it feel like taking your lower lip with your finger and just stretching it." These suavely conceived bowls not only suggest a row of protruding lower lips but, to carry the oral analogy a bit further, bear eerie resemblance to a monstrous set of eroding teeth. In any case, it's a long way from Polish folk dancers or ancient Japanese armor.

Sometimes her carved containers are not instantly identifiable as such. A case in point is the 1995 *Untitled (Three Baskets)*, whose trio of globular shapes clot closely together. At both ends of this amorphous mass are rudely carved handles that, in profile, vaguely resemble human heads. Flopped atop the sculpture's bulky volume are two waffle-thin forms, the smaller covering a single basket opening, the second over the other two openings. So thin and apparently supple are these lids, they seem made of something other than wood. In this strange, rather formless but compelling work, von Rydingsvard seems to allude to a timeless generative process. Unlike her other vessels, where contours are crisply defined, *Untitled (Three Baskets)* appears in the throes of radical transformation. The yeasty, indeterminate mass of the piece looks as if it might be undergoing mitosis, stretching and slowly dividing itself into a trio of containers.

Anatomical references, however arcane, abound throughout her work, even in von Rydingsvard's semi-factual renditions of kitchen objects and farm tools. The 1997 ten-foot-high *Ladle* originally was made to be a giant spoon, but soon she thought of it as a figure whose neck she would "break by sawing through it, thus allowing it to lay its head on the ground in a very vulnerable way." Utilitarian objects transformed in such Brobdingnagian sculptures are like haunting evocations of childhood

surroundings that could, as well, be surviving artifacts from imaginary realms. Von Rydingsvard fantasizes they might have been used by a long-extinct, "primitively potent" race. Indeed, how many strong men would it take to lift the enormous *Ladle*, dip it into one of her cavernous bowls filled with thick soup, then empty it into another?

During her first trip to Poland in 1985, von Rydingsvard came across another domestic object she may have heard of as a child but never actually saw, the humble maglownica, a flat, rasp-surfaced board traditionally used by Polish farm women to soften linen sheets after laundering. Von Rydingsvard recounts, "the linens were so harsh, it was often difficult to sleep on them, for fear of bloodying yourself." Thus, to soften them up while still damp, the sheets were wrapped tightly around a flat wooden bat and vigorously rubbed with the maglownica.

Of the many domestic objects given a startling new identity in her sculptures, none has more personal meaning than the maglownica. So enamored was she of its simple functional shape, von Rydingsvard brought a pair back from Poland and hung them on the walls of her house in Alligerville, New York. She delights in recounting the maglownica's legendary role in Polish folklore. "There's a primitive folk song, where the woman talks about going off with her lover to war, having no understanding of what war really is. But she tells him 'I will go with you to foreign lands, I will go with you to the palace in whatever town you may be, in Krakow or Warsaw. I will go to you there. I will be the maid of the palace while you are fighting the war, and will use not a wooden maglownica but one of gold.'"

While von Rydingsvard's 1995 *Maglownica* bears some resemblance to the lowly object that inspired it, that object was only a point of departure for considerable variations on a theme. In her version, it becomes a cedar plank around whose bumpy surface she tautly wraps translucent membranes of dried cow intestines. Her *Maglownica* also takes on some disquieting human associations. Its spiny protrusions simultaneously suggest human vertebrae, a rib cage, and a bandaged, wounded torso.

For von Rydingsvard, landscape is an inclusive theme, its borders so elastic, all aspects of existence are encompassed. Rich and varied topographies

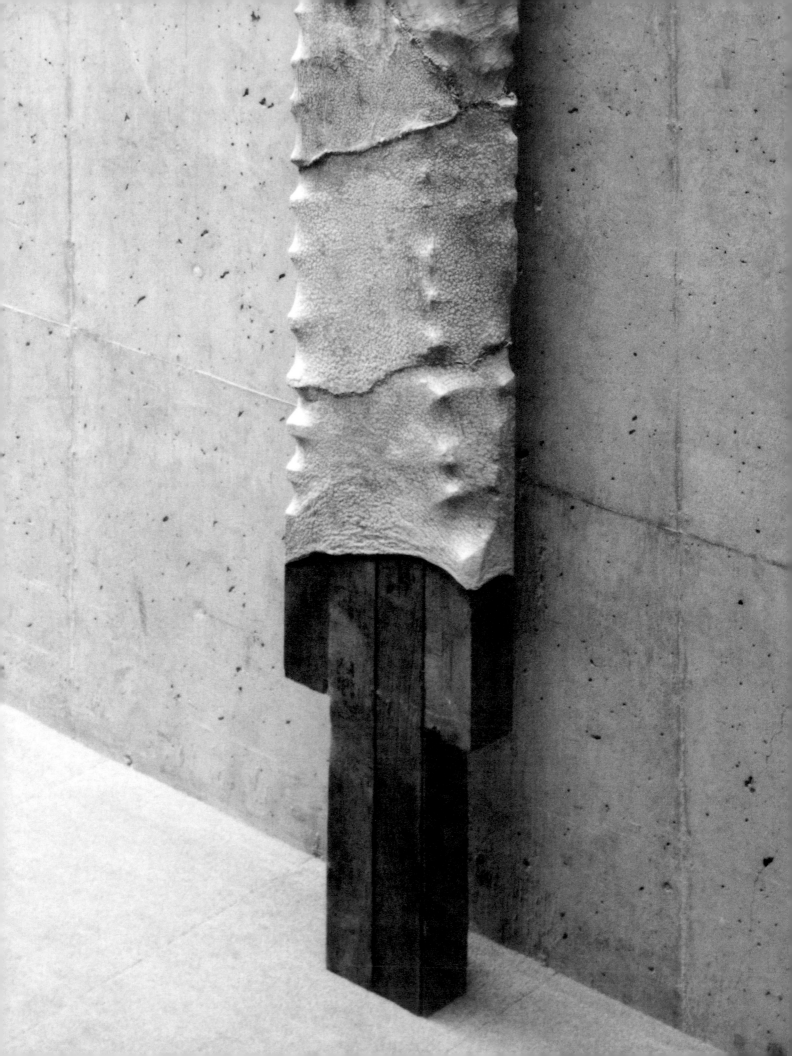

of mountains and valleys, deep canyons and steep, striated cliff walls are constantly summoned up in these darkly toned wood configurations. She regards landscape as a conceptual, not a descriptive, phenomenon that embraces all visible and invisible aspects of nature; she does not distinguish between real-world landscapes and those encountered in dreams. Von Rydingsvard views the psychological landscape that materializes in dreams and half-wakened states as the most important because, within it, memories and feelings become palpable.

Landscape images, primal, even menacing, persist in many von Rydingsvard sculptures, yet their identities, like dream-world objects, are constantly changing. Jagged contours and agitated surfaces encourage freewheeling ruminations about ageless mountains, depthless canyons, and austere, lunar terrain. Nature's epic picturesque qualities appear to be less important to her than the persistence of its life-sustaining processes, no matter how daunting the obstacles. She is entranced by exotic aberrations in nature, especially when growth processes are subverted, as evidenced by the strange swellings on plant stems where insects have bored holes or laid eggs. Von Rydingsvard describes a New York City tree she has observed over the years that manages to thrive "despite having to force its trunk through steel sidewalk grating. It grows at a crazy angle yet, somehow, retains its equilibrium and looks fabulous."

An early sculpture, the light-toned, seven-part *For Weston*, 1978, whose tapering components echo those in the 1976 *Untitled (cones)*, lends itself to readings as various as smooth-surfaced boulders, improbably high mountains, giant prehistoric plant shoots and, on another note, a pride of phalluses vigorously emerging from the ground. Von Rydingsvard sees validity in all these interpretations. As to the latter, she readily avers that sexuality persists throughout her sculpture, because "it's bound in with the anxiety and violence that's inherent in the work."

Often, a von Rydingsvard sculpture that begins as a single unit becomes the starting point for a more ambitiously scaled work. Such is the convoluted history of the 1987 *Zakopane*, a strongly architectural wall piece made of myriad wooden verticals, packed sardine-style next to each other. At first, it was planned as a floor piece, "a relief structure that would feel as

Maglownica (detail), 1995

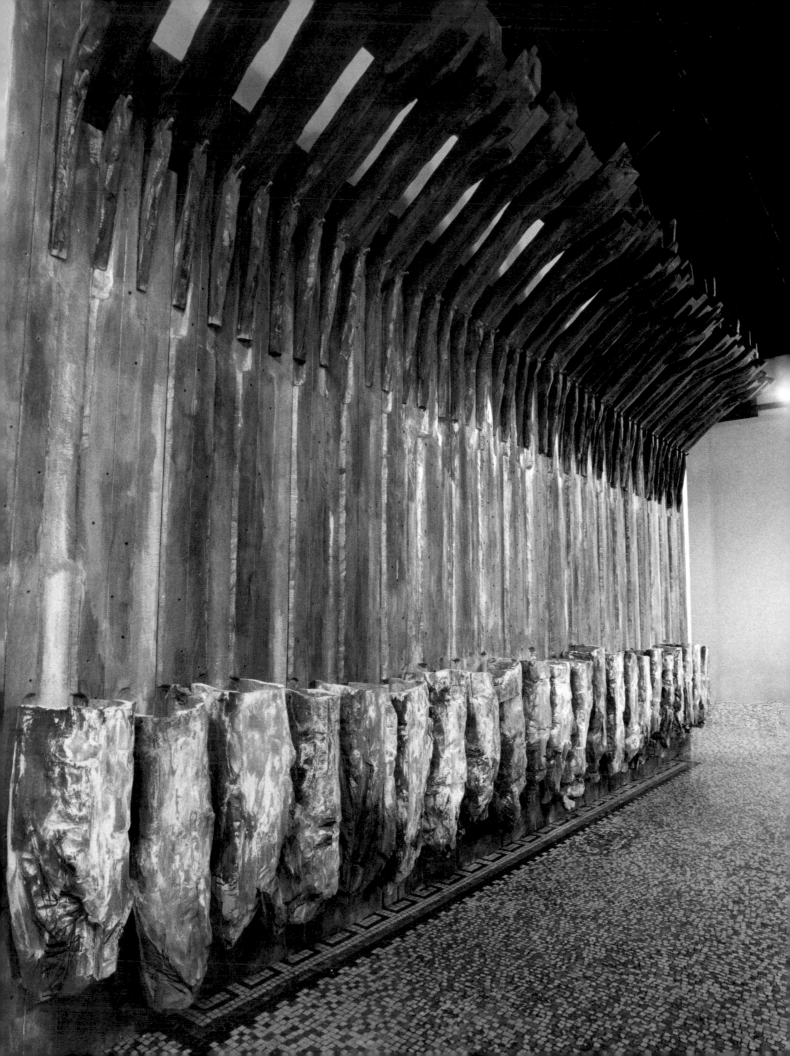

though it were dug into the earth." Its back panel, resting on the ground, was a series of closely fitted boards from which a mass of lead-wrapped dowels, like long fingers, pointed upward. This complex was surrounded by four high rectangular wooden walls. Increasingly unhappy with the results, von Rydingsvard started dismantling it: first the dowels disappeared, then the four-sided enclosure. Finally, she upended what remained of the relief and propped it against a wall. The salvaged construction—five closely fitted vertical lengths of wood—now formed the basis of an entirely new work, but one of such projected scale she was unable to realize it then on her own. Fate intervened in the form of a brief residency at the University of Maryland, where she had the use of a well-equipped woodshop and enough energetic art students to help carry through the huge project. Slowly, inexorably, the five-foot relief stretched into *Zakopane*, a twenty-two-foot wall she felt would "hold" viewers within its atmosphere. Indeed, its angled wooden overhang, like a bizarre lineup of skeletal arms, bent at the elbow, extends protectively and a bit ominously over the spectator's head.

Zakopane, which incongruously bears the name of a picturesque ski resort in southern Poland, is an isolated example of von Rydingsvard's production since it is a flat rather than volumetric composition. She would like to make it even larger some day, she says wistfully, especially if it were permanently installed in a long hall or huge room. If *Zakopane* is unique in her production, the wall theme is not. In fact, walls are prominent in most of her large sculptures, among these *Lace Mountains*, a 1989 mass of sharp-edged forms, as evocative of a deteriorating rubble wall as of jagged mountain contours. Though von Rydingsvard is interested in many of architecture's historical and contemporary expressions, she is especially drawn to its more rudimentary manifestations. She responds, in particular, to the form of dwellings, granaries, and other structures traditionally made of materials like wood, clay, and straw still found in certain tribal and folk societies. During a 1993 trip to Ireland, she and her friend and fellow-sculptor Judy Pfaff wandered through what remained of early Celtic campsites, fascinated by huge U-shaped outlines in the grass where cooking fires once burned. The mystical and physical connections between such traces and the ground they occupy enthrall her. In view of her intense

Zakopane, 1987

29

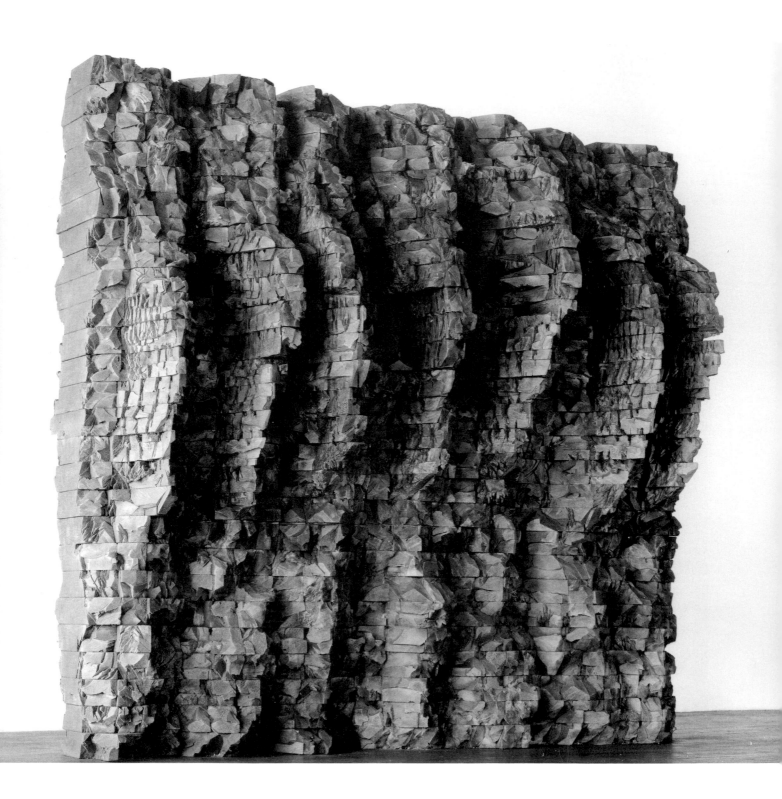

absorption with such phenomena, it is not surprising von Rydingsvard's sculptures suggest relics of extinct cultures. Their configurations and worn surfaces seem to hint at, but never reveal, their histories and many large wooden pieces are so suffused with elegiac feeling it's easy to think of them as fragments of larger entities—shattered columns and towers, and demolished walls. They are like mementos of an ancient but entirely fictional world.

Whether descriptive, like kitchen objects and farm tools, or completely abstract, there are strong connections among all von Rydingsvard sculptures. Whatever their overt or implicit themes, these pieces are closely related in the use of materials, sense of mass, raw-edged contours, and heavily textured, monochromatic surfaces. Beyond such physical connections, her sculptures share certain psychological affinities that contribute to the sense that they are part of a close-knit family of works. These talismanic forms derive as much from how von Rydingsvard mines her own unconscious as from the painstaking fabrication she uses in the studio. At its core, von Rydingsvard's sculpture is a profoundly humanistic distillation of remembered objects, places, and events. An art of revelation, its universal imagery invites us to reflect on what may exist in the recesses of our own unconscious.

Lace Mountains, 1989

Works in the Exhibition

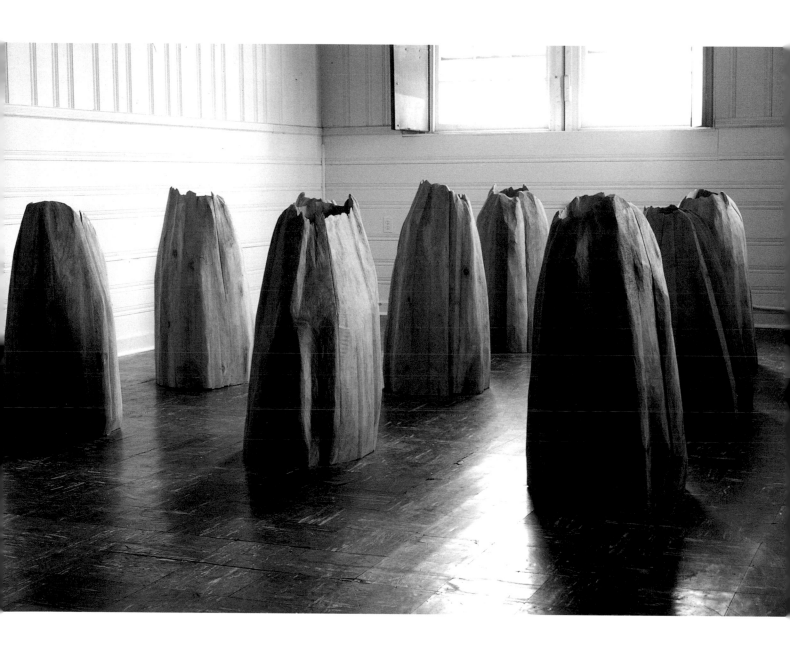

Untitled (cones), 1976

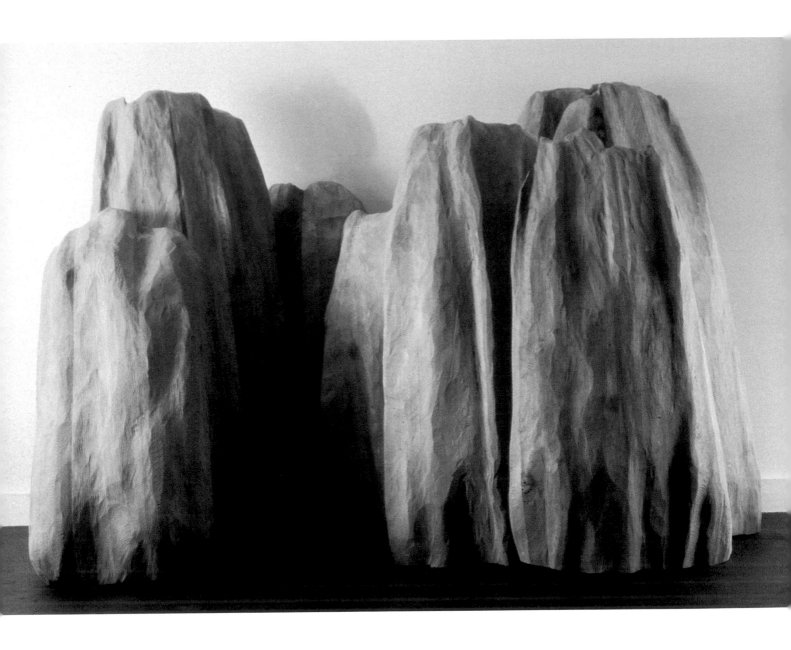

34 *For Weston*, 1978

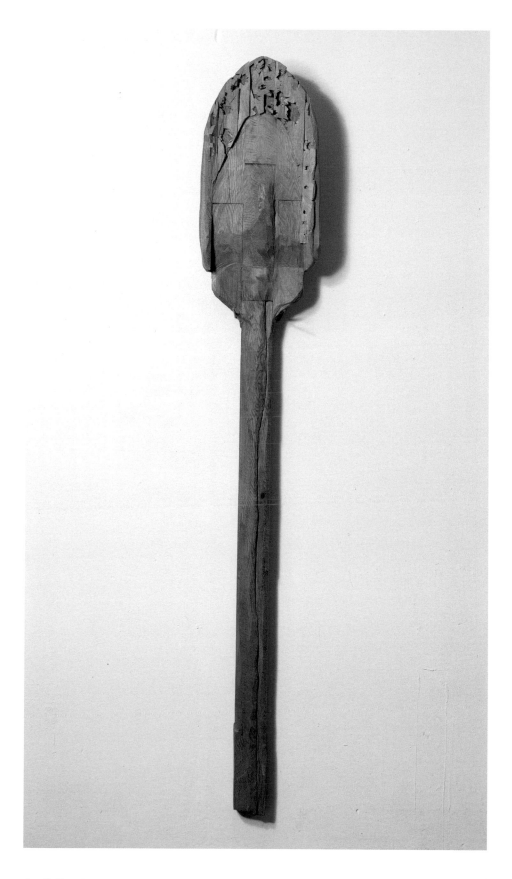

Paul's Shovel, 1987 35

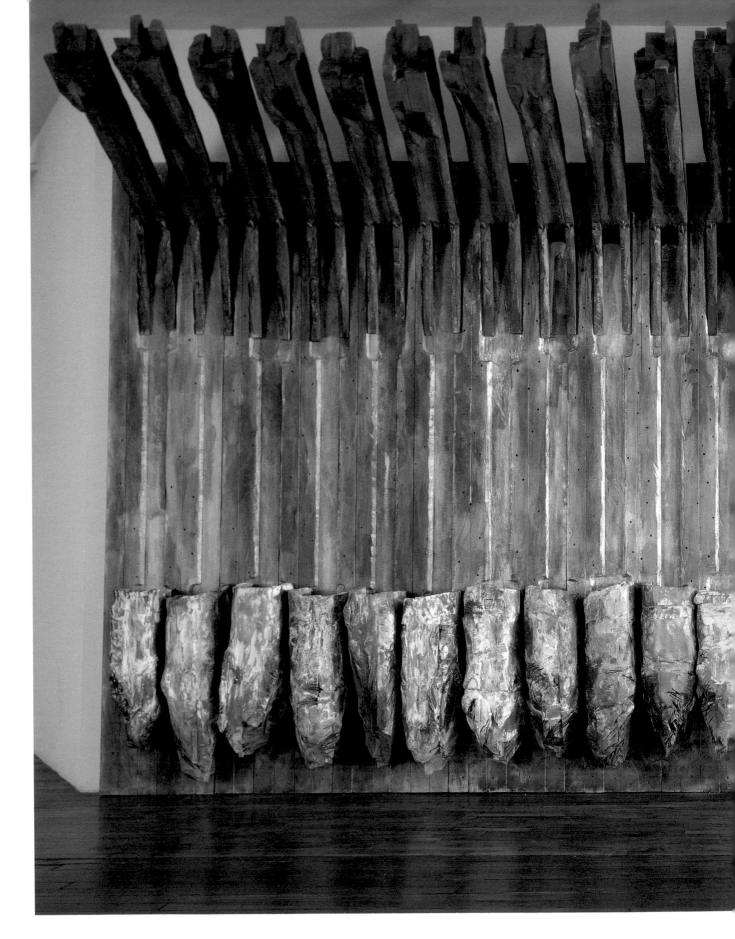

36

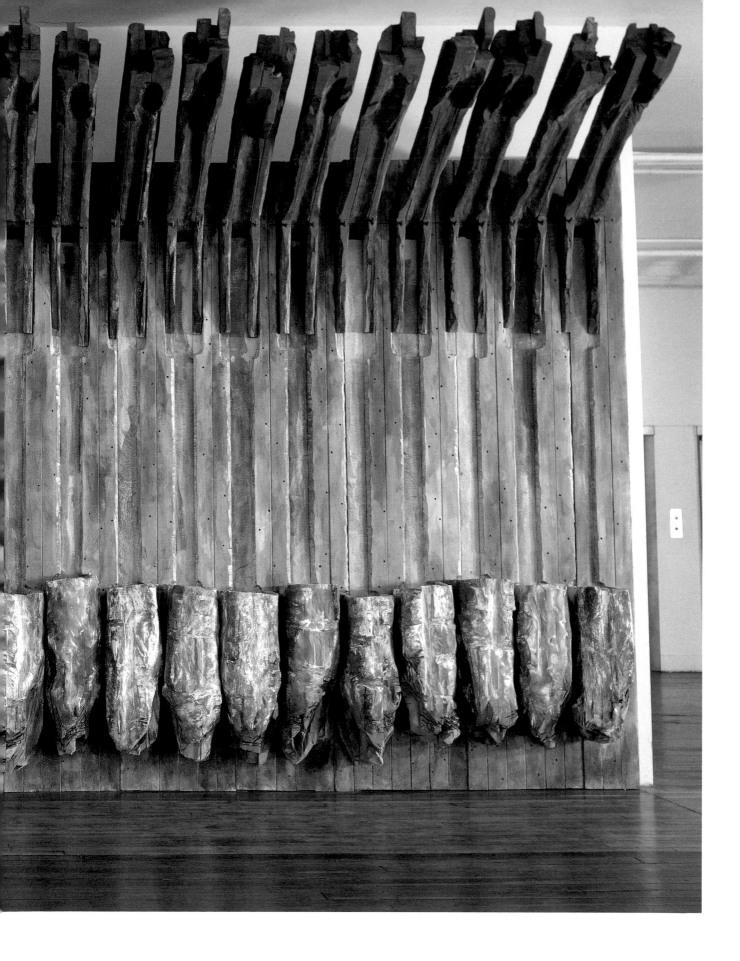

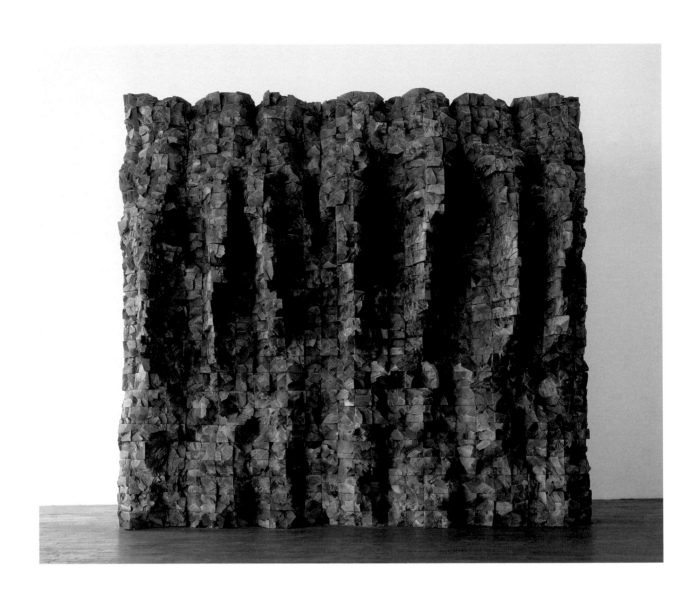

Lace Mountains, 1989
Detail, right

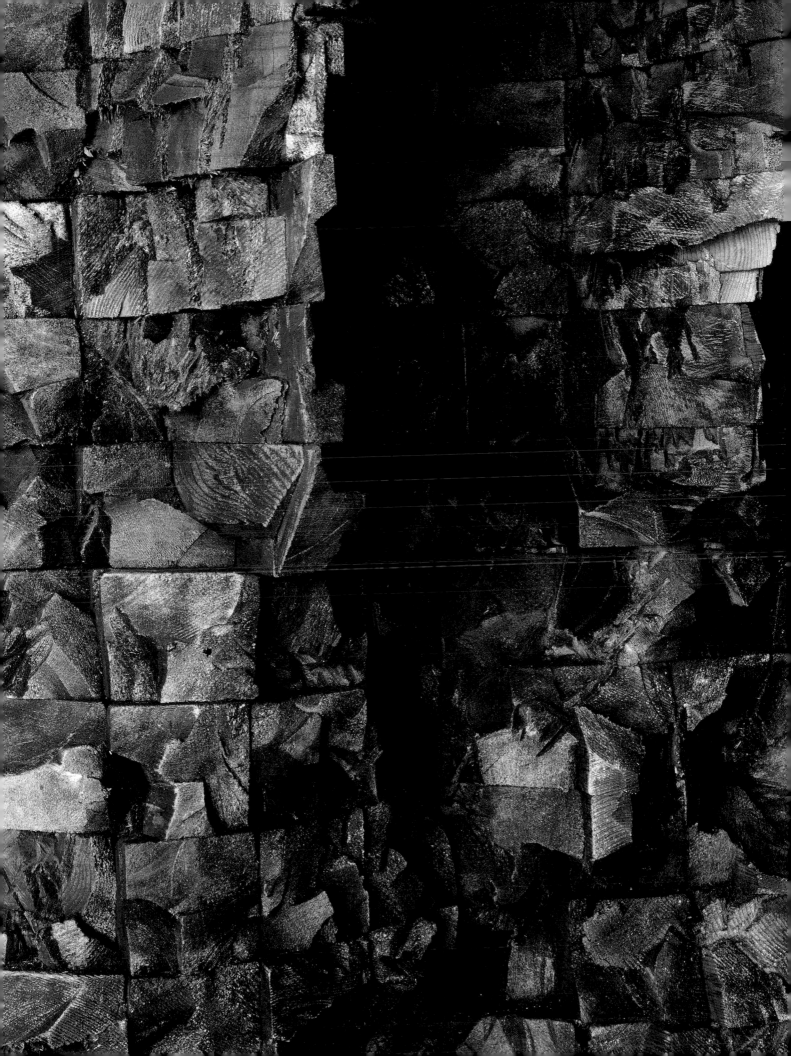

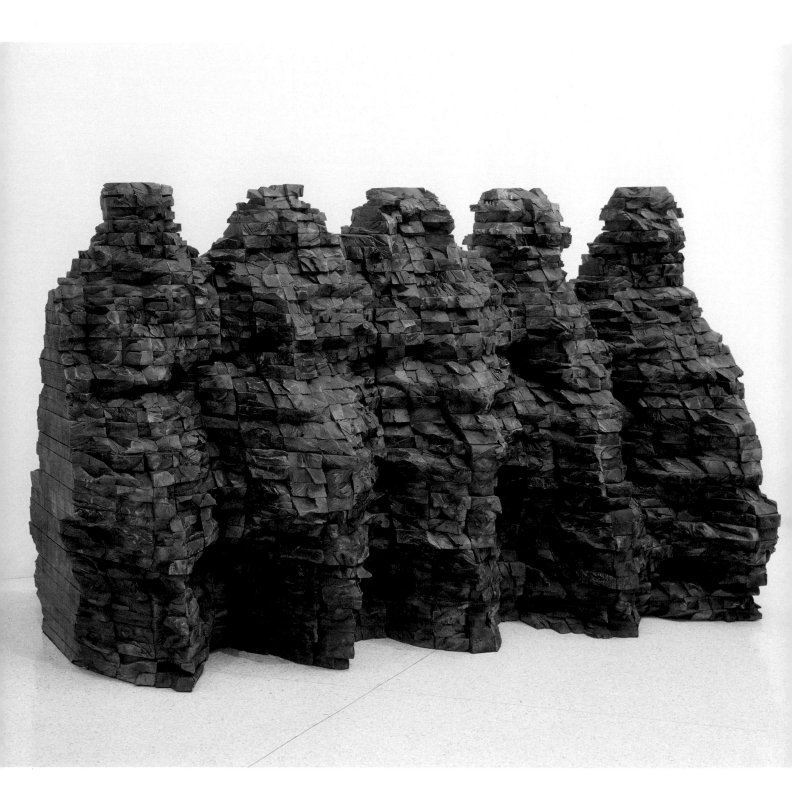

Five Mountains, 1989

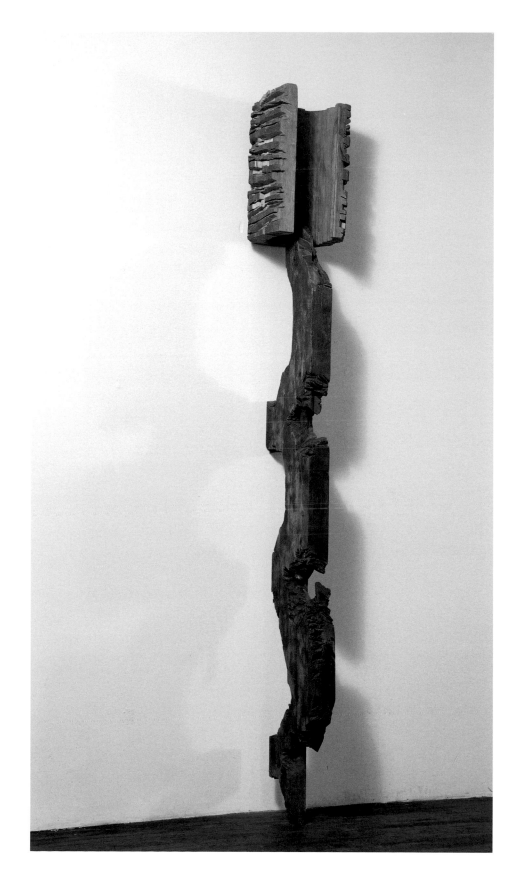

Johnny Angel, 1991

41

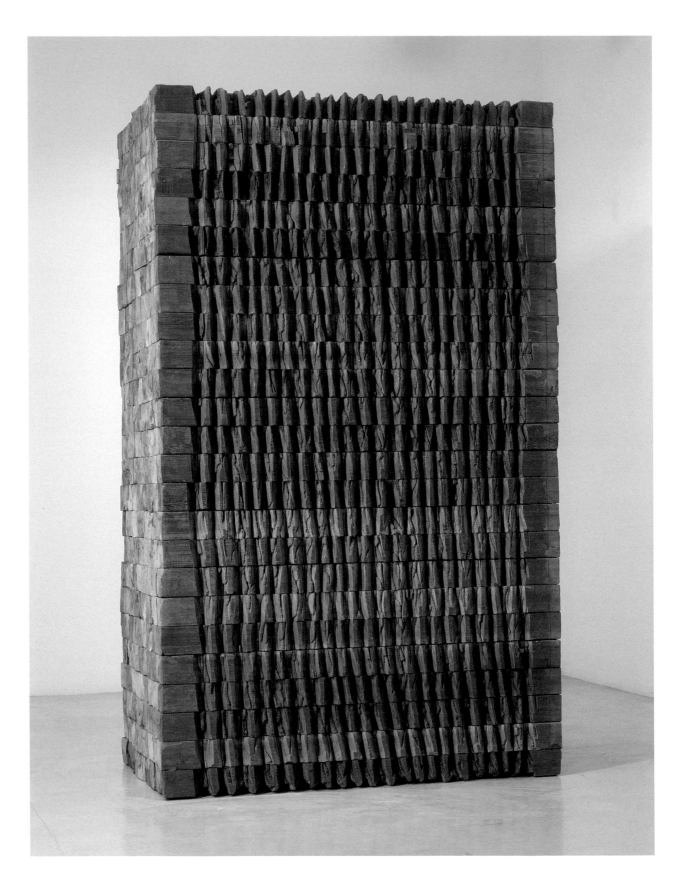

Dla Gienka (For Gene), 1991–1993

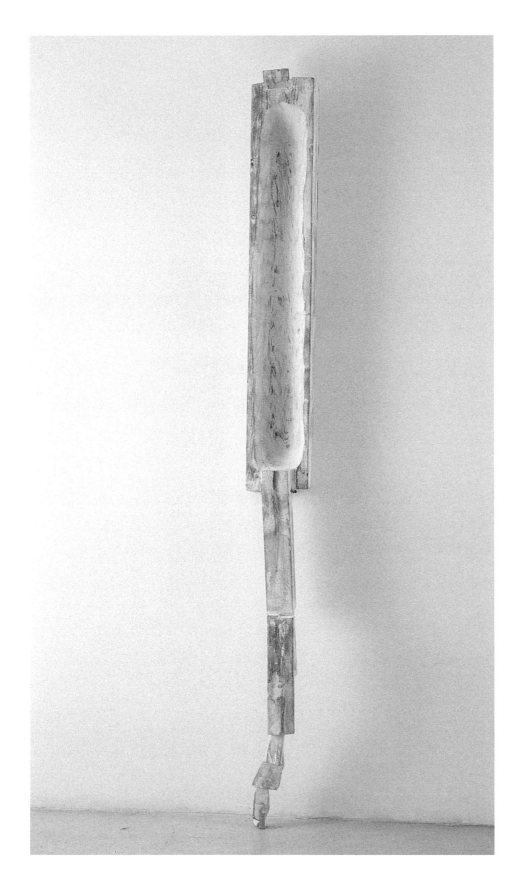

Spoon Shovel, 1991

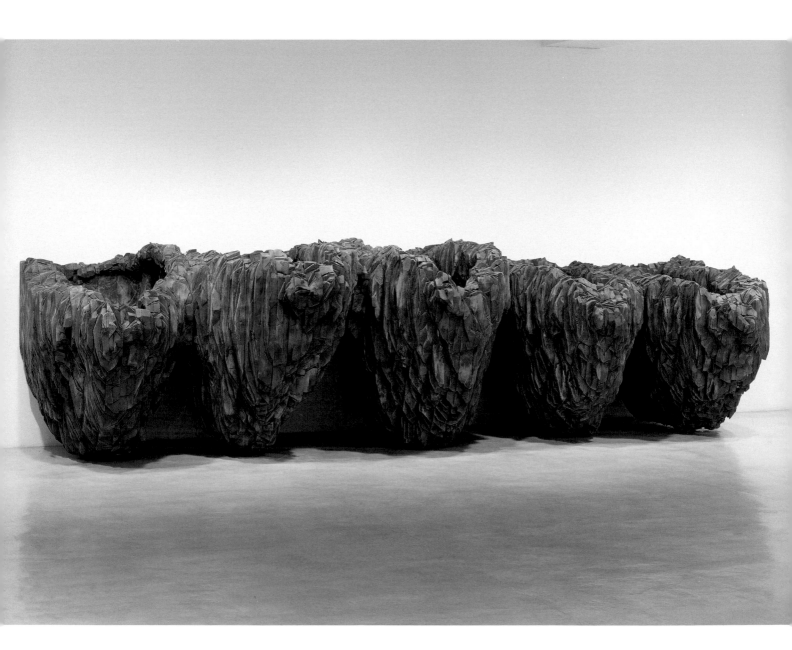

44 *Krasavica*, 1992–1993

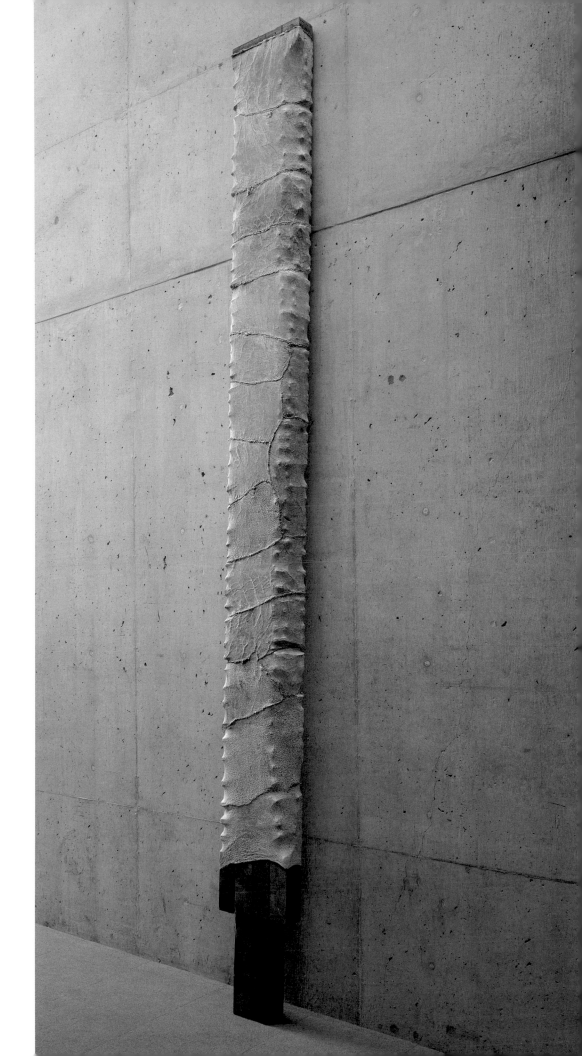

Maglownica, 1995

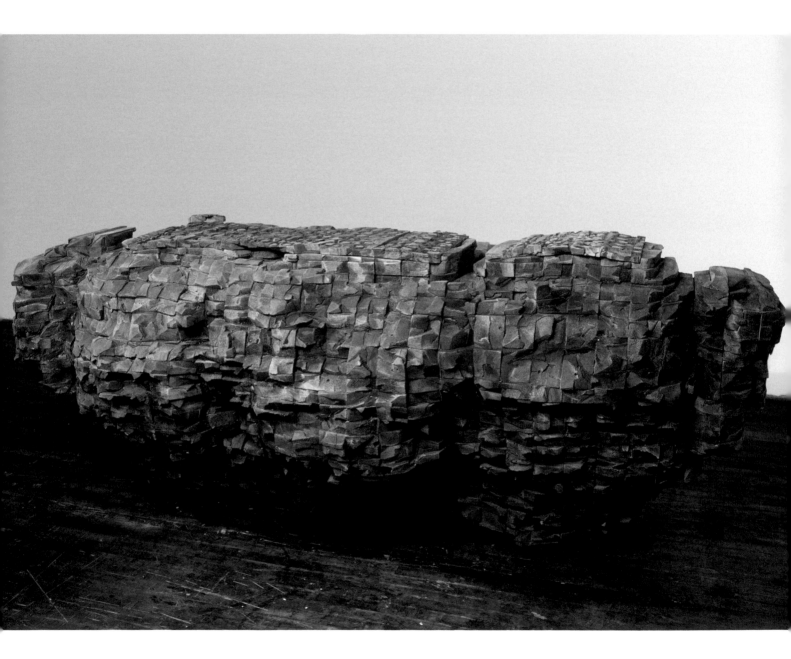

Untitled (Three Baskets), 1995

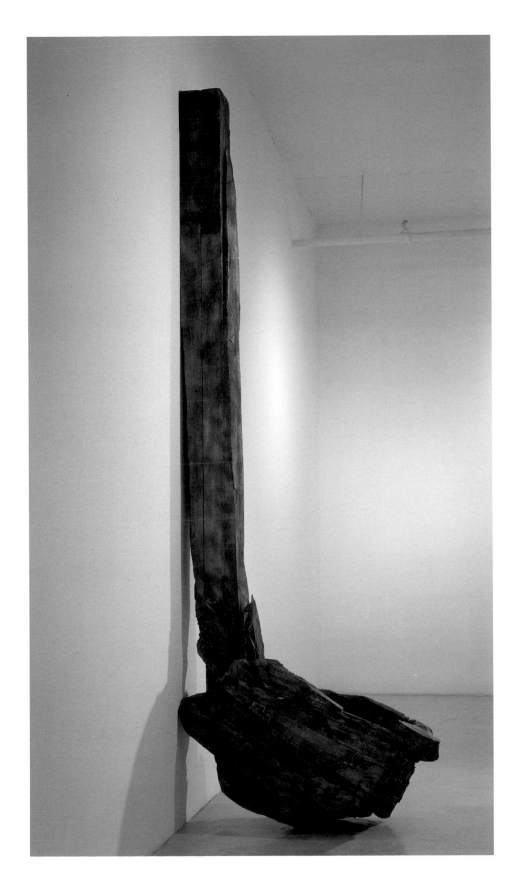

Ladle, 1997

47

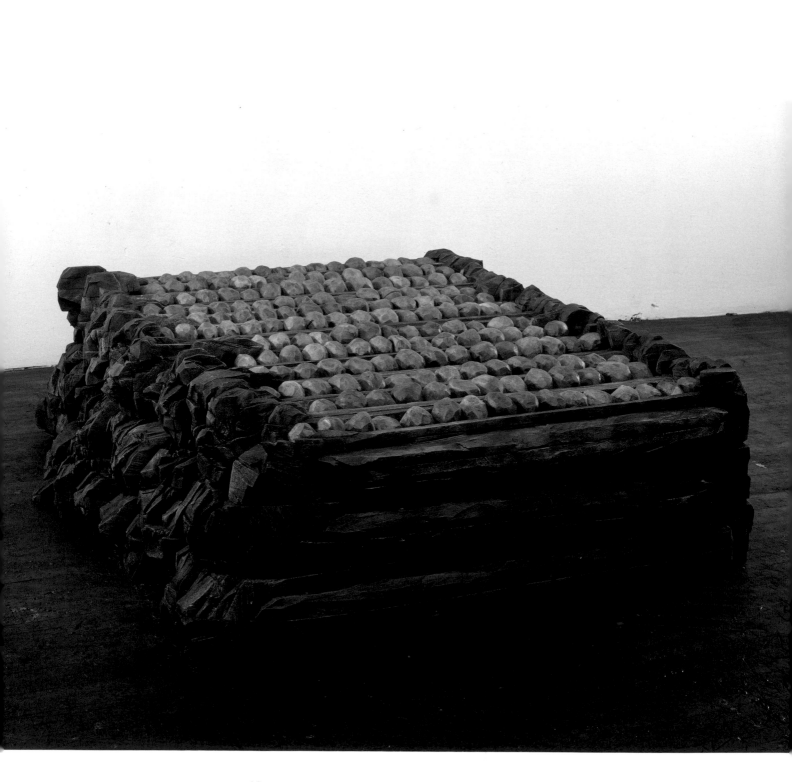

Mother's Purse, 1997

Exhibition Checklist

Dimensions are in inches; height precedes width precedes depth. Unless otherwise noted, all works are collection of the artist, courtesy Galerie Lelong, New York.

Untitled (cones), 1976
Cedar
42 x 156 x 180

For Weston, 1978
Cedar
48 x 66 x 18
Collection of Vera List

Paul's Shovel, 1987
Cedar
83 x 13 x 5
Collection of Paul Greengard

Zakopane, 1987
Cedar and paint
138 x 264 x 36

Lace Mountains, 1989
Cedar and graphite
96 x 96 x 36

Five Mountains, 1989
Cedar, stain and graphite
$61^{1}/_{4}$ x 102 x 70
Collection Walker Art Center, Minneapolis
T.B. Walker Acquisition Fund, 1990

Johnny Angel, 1991
Cedar and graphite
112 x 14 x $18^{1}/_{2}$

Dla Gienka (For Gene), 1991–1993
Cedar and graphite
88 x $53^{1}/_{4}$ x $31^{3}/_{4}$

Spoon Shovel, 1991
Cedar and whitewash
99 x $8^{1}/_{2}$ x $10^{1}/_{2}$

Krasavica, 1992–1993
Cedar and graphite
54 x $205^{3}/_{4}$ x 59

Maglownica, 1995
Cedar and tripe
148 x 14 x $3^{1}/_{2}$

Untitled (Three Baskets), 1995
Cedar and graphite
40 x 103 x 47

Ladle, 1997
Cedar and graphite
120 x $42^{1}/_{2}$ x 20

Mother's Purse, 1997
Cedar and graphite
$24^{1}/_{2}$ x 78 x 91

Solo Exhibitions

1998 Madison Art Center, Wisconsin.
Exhibition travels to the Hood Museum of Art,
Dartmouth College, Hanover,
New Hampshire; the Chicago Cultural Center,
Illinois; The Contemporary Museum,
Honolulu, Hawaii.

Byron Cohen/Lennie Berkowitz Gallery
for Contemporary Art, Kansas City, Missouri.

1997 Yorkshire Sculpture Park, Wakefield, England,
and The Nelson-Atkins Museum of Art,
Kansas City, Missouri. Exhibition travels to
The Indianapolis Museum of Art, Indiana.

Galerie Lelong, New York.

1996 Museum of Art, Rhode Island School
of Design, Providence.

1995 University Art Gallery, Fine Arts Center,
University of Massachusetts at Amherst.

University of Wyoming Art Museum, Laramie.

1994 Metro Tech Plaza, Brooklyn, New York.

Weatherspoon Art Gallery,
University of North Carolina, Greensboro.

Galerie Lelong, New York.

1992–1994
Storm King Art Center, Mountainville,
New York.

1992 Center for Contemporary Art Ujazdowski
Castle, Warsaw, Poland.

1991 Lorence-Monk Gallery, New York.

1990 Lorence-Monk Gallery, New York.

The Fabric Workshop, Philadelphia.

Capp Street Project, San Francisco.

1989 Feigenson/Preston Gallery,
Birmingham, Michigan.

Cranbrook Art Museum,
Bloomfield Hills, Michigan.

1988 Exit Art, New York.

Laumeier Sculpture Park,
St. Louis, Missouri.

1985 Studio Bassanese, Trieste, Italy.

1984 Bette Stoler Gallery, New York.

1982 Rosa Esman Gallery, New York.

1981 Rosa Esman Gallery, New York.

1980 55 Mercer, New York.

1979 55 Mercer, New York.

1978 Robert Freidus Gallery, New York.

1977 55 Mercer, New York.

Selected Public Collections

The Aldrich Museum of Contemporary Art
Ridgefield, Connecticut

William Benton Museum of Art
University of Connecticut, Storrs, Connecticut

The Brooklyn Museum
Brooklyn, New York

Center for Contemporary Art Ujazdowski Castle
Warsaw, Poland

The Detroit Institute of Arts
Detroit, Michigan

T.F. Green Airport
Providence, Rhode Island

High Museum of Art
Atlanta, Georgia

Hood Museum of Art
Dartmouth College, Hanover, New Hampshire

Laumeier Sculpture Park
St. Louis, Missouri

The Metropolitan Museum of Art
New York, New York

Sidney Mishkin Gallery,
Baruch College, The City University of New York

Neuberger Museum of Art
State University of New York at Purchase

Orlando Museum of Art
Orlando, Florida

Storm King Art Center
Mountainville, New York

Virginia Museum of Fine Arts
Richmond, Virginia

Walker Art Center
Minneapolis, Minnesota

Whitney Museum of American Art
New York, New York

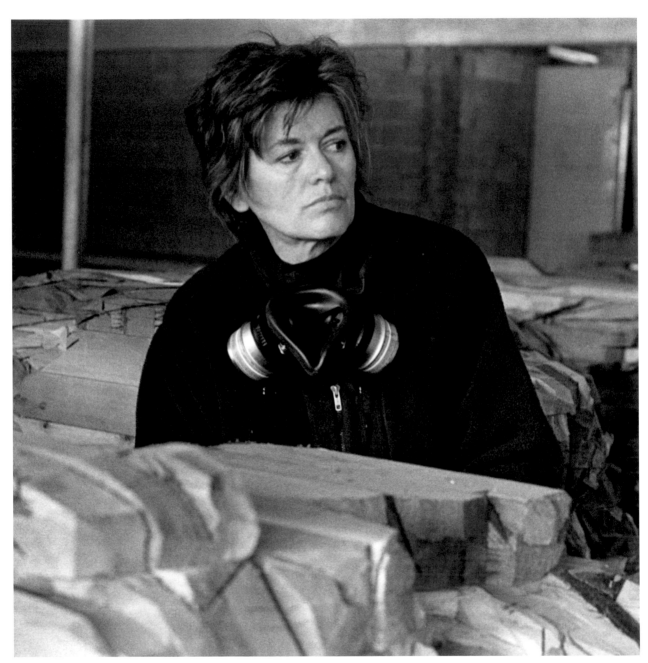

Ursula von Rydingsvard in her studio

Chronology

1942	Born July 26 in Deensen, Germany, to Ignacy and Kunegunda Karoliszyn. During a five-year period beginning in 1945, the family of nine remained together but moved frequently, living in German refugee camps for displaced Poles.
1950	The Karoliszyns emigrate to the United States and settle in Plainville, Connecticut.
1960–1962	Enters the University of New Hampshire, Durham. Studies include drawing and painting (with Christopher Cook) and art history (with Jim Fasanelli).
1962–1965	Receives B.A. and M.A. from the University of Miami, Coral Gables, Florida. Marries Milton von Rydingsvard in 1963.
1969–1970	Studies at the University of California at Berkeley. Gives birth to daughter, Ursula Ann von Rydingsvard.
1971–1973	Moves to New Britain, Connecticut; studies painting and drawing at the New School for Social Research, New York.
1973–1974	Divorces Milton von Rydingsvard. Enters master of fine arts program at Columbia University, New York; professors include Ronald Bladen, Jean Linder, Meyer Schapiro, George Sugarman and Sahl Swarz.
	Works at The Museum of Modern Art during the summer. Explores welded steel as a medium for sculpture.
1975	Receives M.F.A. in sculpture from Columbia University. Attends classes led by Dore Ashton at Cooper Union. Initiates use of cedar, later to become a signature element of her work. Receives Fulbright-Hays Grant to travel to Poland; political unrest prevents immediate travel.
1977–1978	Joins 55 Mercer, an artists' cooperative based in SoHo. In addition to solo exhibitions at 55 Mercer and at Robert Freidus Gallery, New York, von Rydingsvard's work is included in *Wood* at Nassau County Museum of Fine Arts, Roslyn, New York, and in *Indoor-Outdoor Exhibition* at the Institute for Art and Urban Resources, Long Island City, New York. Receives grant from New York State Council on the Arts.
	Appointed assistant professor, Pratt Institute, New York. Meets artists Carl Andre, Sol LeWitt and Robert Ryman.

1979	Exhibits two major works: *Koszarawa*, in *Wave Hill: The Artist's View*, New York and at the Neuberger Museum, State University of New York; and *Song of a Saint (Saint Eulalia)*, Artpark, Lewiston, New York. Receives grant from the National Endowment for the Arts.
1980	Commissioned to create *Saint Martin's Dream* by Art on the Beach program sponsored by Creative Time, Battery Park City landfill, New York. Receives grant from Creative Artists Program Service. Travels to Guatemala and Mexico. Appointed assistant professor, Fordham University, New York.
1981	Teaches at the School of Visual Arts, New York. Returns to Europe for the first time since her family's emigration; visits France and Italy.
1982	Appointed assistant, then associate professor, Sculpture Department, Yale School of Art, Connecticut. Meets artist Judy Pfaff.
1983	Granted Guggenheim Fellowship. Commissioned by City of Dayton, Ohio, to participate in Dayton City Beautiful Project.
1984	Participates in group exhibition, *Contemporary Art at One Penn Plaza*, New York. Awarded Mark di Suvero Athena Foundation Grant.
1985	Marries neuroscientist Paul Greengard. Solo exhibition at Studio Bassanese, Trieste, Italy. Included in *Selections from the Collection*, The Aldrich Museum of Contemporary Art, Ridgefield, Connecticut. Receives Griswald Travel Grant from Yale University and travels to Poland.
1986	Receives appointment in the Graduate Division, School of Visual Arts, New York. Awarded Individual Artists Grant from the National Endowment for the Arts. Continues travels; visits Scandinavia. Initiates use of graphite in combination with cedar.
1987	Featured in a number of group exhibitions, including *Sculpture of the Eighties: Aycock, Ferrara, Frank, Lasch, Miss, Pfaff, Saar, Sperry, von Rydingsvard, Zucker* (Queens Museum of Art, Flushing, New York) and *Standing Grounds* (Contemporary Arts Center, Cincinnati, Ohio). Awarded second Individual Artists Grant from the National Endowment for the Arts. Returns to Italy.
1988	Solo exhibitions at Laumeier Sculpture Park, St. Louis, Missouri, and at Exit Art, New York. Work enters the permanent collections of The Metropolitan Museum of Art, New York; The Brooklyn Museum, New York; and the Laumeier Sculpture Park, St. Louis. Group exhibition in Santa Barbara, California. Travels to France.

54

1989	Solo exhibitions at Cranbrook Art Museum, Bloomfield Hills, Michigan, and Feigenson/Preston Gallery, Birmingham, Michigan. Group exhibition at the Contemporary Arts Center, Cincinnati, Ohio. Father dies.
1990	Produces work for Capp Street Project, San Francisco, and for the Minneapolis Sculpture Garden. Work enters permanent collection of the Walker Art Center. Solo exhibitions at The Fabric Workshop, Philadelphia and Lorence-Monk Gallery, New York. Group exhibition, *Out of Wood*, at the Whitney Museum at Philip Morris, New York. Visits Poland.
1991	Receives honorary doctorate from Maryland Institute College of Art, Baltimore. Group exhibition at Zacheta Gallery, Warsaw, Poland.
1992	Solo exhibitions at Center for Contemporary Art Ujazdowski Castle, Warsaw, Poland, and Storm King Art Center, Mountainville, New York. Collaborates with Judy Pfaff to create an installation for the Cultural Space/The Laboratory, New York. Work enters the permanent collection of the Virginia Museum of Fine Arts, Richmond. Travels to Norway.
1993	Travels to Ireland.
1994	Solo exhibitions at Metro Tech Plaza, Brooklyn, New York; Weatherspoon Art Gallery, Greensboro, North Carolina; and Galerie Lelong, New York. Participates in *Three Rivers Festival*, Pittsburgh, Pennsylvania. Group exhibitions include *Visions of America: Landscape as Metaphor in the Late Twentieth Century* (Denver Art Museum, Colorado, and the Columbus Museum of Art, Ohio) and *Beyond Nature: Wood into Art* (Lowe Art Museum, University of Miami, Coral Gables, Florida). Works enters permanent collection of Storm King Art Center, Mountainville, New York. Granted Sculpture Award, American Academy of Arts and Letters. Returns to Italy.
1995	Solo exhibitions at the University of Wyoming Art Museum, Laramie, and University Gallery, University of Massachusetts at Amherst. Work enters the permanent collections of the Whitney Museum of American Art, New York; the High Museum of Art, Atlanta, Georgia; the Orlando Museum of Art, Florida; and the Hood Museum of Art, Dartmouth College, Hanover, New Hampshire. Participates in group exhibition, *Beyond Gender*, at Snug Harbor Cultural Center, Staten Island, New York. Travels to Ukraine and Poland.

1996	Solo exhibition at the Museum of Art, Rhode Island School of Design, Providence. Granted the Alfred Jurzykowski Foundation Award in Fine Art.
1997	Solo exhibition at Yorkshire Sculpture Park, Wakefield, England (traveling exhibition organized by The Nelson-Atkins Museum of Art and by Yorkshire Sculpture Park, traveling to The Indianapolis Museum of Art). Solo exhibition at Galerie Lelong, New York. Receives award from Joan Mitchell Foundation. Travels to Turkey. Completes outdoor commission for Microsoft Corporation.
1998	Solo exhibition at the Madison Art Center, Wisconsin. Exhibition travels to the Hood Museum of Art, Dartmouth College, Hanover, New Hampshire; the Chicago Cultural Center, Illinois; and The Contemporary Museum, Honolulu. Work enters permanent collection of Sidney Mishkin Gallery, Baruch College, The City University of New York.

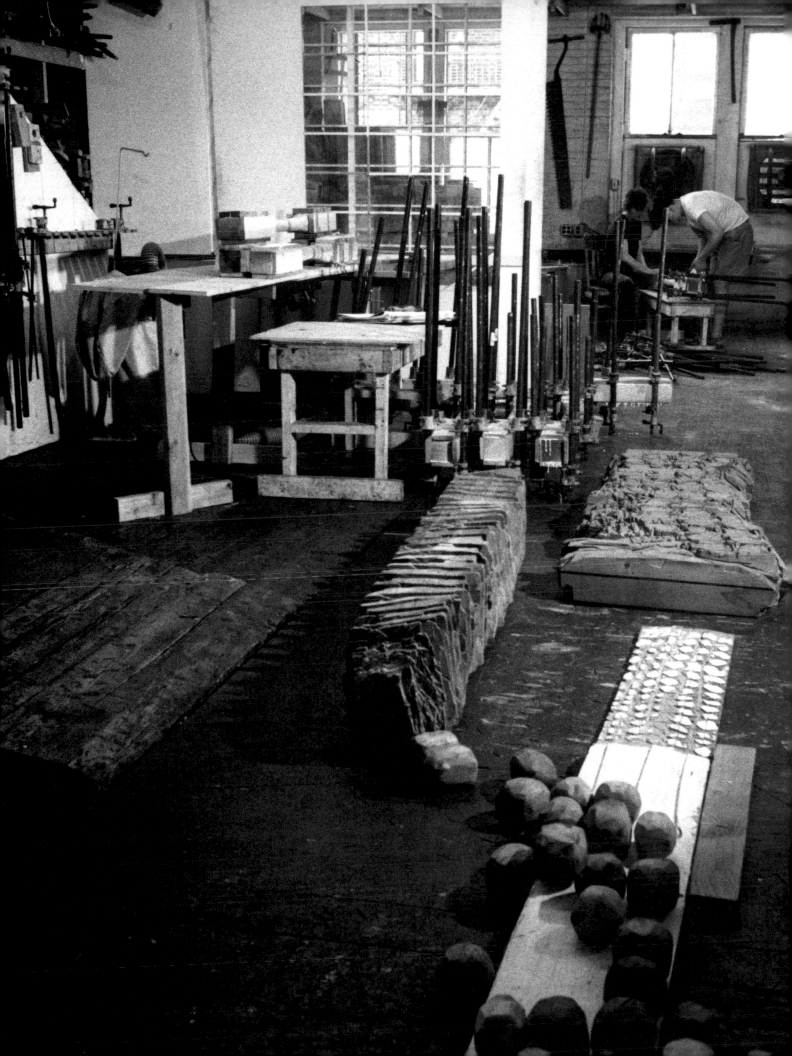

Selected Bibliography

Books and Exhibition Catalogues

Alloway, Lawrence. *Ursula von Rydingsvard*. New York: Bette Stoler Gallery, 1984.

Ashton, Dore. *Home Show: Ten Artists' Installations in Ten Santa Barbara Homes*. Santa Barbara, California: Santa Barbara Contemporary Arts Forum, 1988.

Ashton, Dore; Bartelik, Marek; Megged, Matti. *The Sculpture of Ursula von Rydingsvard*. New York: Hudson Hills Press, 1996.

Brenson, Michael. *Ursula von Rydingsvard: Sculpture*. Mountainville, New York: Storm King Art Center, 1992.

Brenson, Michael; Emont Scott, Deborah. *Ursula von Rydingsvard*. The Nelson-Atkins Museum of Art and the Yorkshire Sculpture Park, 1997.

Collischan Van Wagner, Judy K. *Lines of Vision: Drawings by Contemporary American Women*. New York: Hudson Hills Press, 1989.

Feinberg, Jean E. *Ursula von Rydingsvard: Sculpture*. Storrs, Connecticut: Jorgensen Gallery, University of Connecticut at Storrs, 1980.

Friedman, Martin. *Visions of America: Landscape as Metaphor in the Late Twentieth Century*. New York: Harry N. Abrams for the Denver Art Museum and the Columbus Museum of Art, 1994.

Onorato, Ronald. *Ursula von Rydingsvard and Vito Acconci: Sculpture at Laumeier*. St. Louis: Laumeier Sculpture Park, 1990.

Ostrow, Saul. *Ursula von Rydingsvard*. New York: Lorence-Monk Gallery, 1990.

Phillips, Patricia. *Ursula von Rydingsvard: Sculpture*. Warsaw: Center for Contemporary Art Ujazdowski Castle, 1993.

Sims, Lowery S. *Sculpture of the Eighties*. Flushing, New York: Queens Museum, 1987.

Strauss, David Levi, ed. *Capp Street Project 1989–1990: Artists in Residence and Experimental Projects*. San Francisco: Capp Street Project AVT, 1991.

Varnedoe, Kirk; Macklowe, Linda; and Randolph, Suzanne. *Wave Hill: The Artist's View*. Bronx, New York: Wave Hill, 1979.

Yau, John. *Ursula von Rydingsvard*. New York: Exit Art, 1988.

Yau, John. *Diverse Representations 1990*. Morristown, New Jersey: Morris Museum, 1990.

Zimmer, William; and Collischan Van Wagner, Judy K. *Judith Murray: Painting, Ursula von Rydingsvard: Sculpture*. Brookville, New York: Hillwood Art Gallery, Long Island University, 1985.

Articles

Atkins, Robert. "Ursula von Rydingsvard." *7 Days* 1, no. 4 (April 20, 1988): 51.

Baker, Kenneth. "Landscape That Fills a Room." *San Francisco Chronicle*, December 13, 1990, E3.

Bartelik, Marek. "Ursula von Rydingsvard, Galerie Lelong." *Artforum* 33, no. 2 (October 1994): 102–103.

Berman, Avis. "Ursula von Rydingsvard: Life under Siege." *Artnews* 87, no. 10 (December 1988): 97–98.

Brenson, Michael. "Sculptors Find New Ways with Wood." *New York Times*, December 2, 1984, sec. 2, 29.

Brenson, Michael. "Setting Free in Images in Big Beams of Wood." *New York Times*, April 1, 1988, C32.

Brenson, Michael. "Wood." *New York Times*, June 7, 1985, C24.

Clothier, Peter. "Ursula von Rydingsvard." *Artspace* 16, no. 5 (September–October 1992): 58–59.

Cotter, Holland. "Sculpture under the Sky: Free, Daring and Soon Departed." *New York Times*, August 26, 1994, C1, C25.

Gardner, Paul. "Do Titles Really Matter?" *Artnews* 91, no. 2 (February 1992): 97.

Gibson, Eric. "Decade in Review." *Sculpture* 8, no. 3 (May–June 1989): 21, 23.

Glueck, Grace. "Ursula von Rydingsvard." *New York Times*, April 18, 1980, C22.

Glueck, Grace. "Ursula von Rydingsvard." *New York Times*, November 5, 1982, C18.

Glueck, Grace. "Ursula von Rydingsvard." *New York Times*, February 24, 1997, B2.

Graziani, Ron. "The Home Show: Public Art in Private Places," *Santa Barbara Magazine* 14 (November 1988): 52–61.

Harris, Susan. "Ursula von Rydingsvard." *Arts Magazine* 57, no. 4 (December 1982): 46.

Henry, Gerrit. "Ursula von Rydingsvard at Rosa Esman." *Art in America* 71, no. 5 (May 1983): 173–174.

Kimmelman, Michael. "Intonations in Wood of Ritual and Refugee Camps." *New York Times*, July 17, 1992, C21.

Larson, Kay. "Inside Out." *New York Magazine* 25, no. 24 (June 15, 1992): 100–101.

Larson, Kay. "Ursula von Rydingsvard." *New York Magazine* 21, no. 19 (May 9, 1988): 81.

Levi Strauss, David. "Sculpture as Refuge." *Art in America* 81, no. 2 (February 1993): 89–92, 125.

Lippard, Lucy. "'Wood' at the Nassau County Museum." *Art in America* 65, no. 6 (November–December 1977): 136–137.

Lubell, Ellen. "Ursula von Rydingsvard." *Arts Magazine* 52, no. 1 (September 1977): 38.

Mahoney, Robert. "Ursula von Rydingsvard (Lorence-Monk Gallery, March 3–31)." *Arts Magazine* 64 (Summer 1990): 94.

McFadden, Sarah. "Going Places, Part II: The Outside Story." *Art in America* 68, no. 6 (Summer 1980): 51–61.

Miro, Marsha. "Vulnerability and Ritual Live in Cedar Forms." *Detroit Free Press*, February 12, 1989, 3C.

Newhall, Edith. "Ursula von Rydingsvard, Galerie Lelong." *Artnews* 93, no. 7 (September 1994): 167.

Olejarz, Harold. "Ursula von Rydingsvard." *Arts Magazine* 53, no. 5 (January 1979): 17.

Phillips, Patricia C. "Ursula von Rydingsvard, Bette Stoler Gallery." *Artforum* 23, no. 1 (September 1984): 111.

Phillips, Patricia C. "Ursula von Rydingsvard: Storm King Art Center." *Artforum* 31, no. 1 (September 1992): 101.

Princenthal, Nancy. "Six Sculptors." *Artnews* 82, no. 7 (September 1983): 194, 198.

Raven, Arlene. "Double Bed (Judy Pfaff and Ursula von Rydingsvard: Zygmunt)." *Village Voice* 37, no. 10 (March 10, 1992): 91.

Raynor, Vivien. "Art: Seven Sculptors at Penn Plaza." *New York Times*, June 15, 1984, C23.

Raynor, Vivien. "Changes at a Sculpture Park." *New York Times*, August 22, 1993, sec. 13NJ, 15.

Raynor, Vivien. "Sculptures of Wood in a Wooden Setting." *New York Times*, September 20, 1992, C26.

Russell, John. "Invitational Exhibition at Rosa Esman Gallery." *New York Times*, June 27, 1980, C24.

Russell, John. "Review." *New York Times*, November 26, 1976, C16.

Russell, John. "Ursula von Rydingsvard (Rosa Esman Gallery)." *New York Times*, April 3, 1981, C23.

Schmerler, Sarah. "Ursula von Rydingsvard." *Time Out New York*, no. 74 (February 20–27, 1997): 36.

Spring, Justin. "Ursula von Rydingsvard: Galerie Lelong." *Artforum* (May 1997).

Tully, Judd. "Ursula von Rydingsvard." *Arts Magazine* 54 (May 1980): 22.

Viney, Jill. "A Rich, Redemptive Journey: Interview by Jill Viney." *Sculpture* 8, no. 8 (November–December 1989): 32–35.

Von Rydingsvard, Ursula. "Thoughts about My Work." *Journal of Artists* 6 (Spring 1986): 45–47.

Zimmer, William. "Art on the Beach." *SoHo Weekly News* 7, no. 39 (June 25–July 1, 1980): 39.

Zimmer, William. "Ursula von Rydingsvard, Exit Art, New York City." *Sculpture* 7, no. 4 (July–August 1988): 26.

Zimmer, William. "Von Rydingsvard at Rosa Esman." *Art Gallery Scene*, November 16, 1982, 26.

Madison Art Center Staff

Director's Office
Stephen Fleischman, Director
Ina Dick, Assistant to the Director

Administrative Department
Michael Paggie, Business Manager
Judy Schwickerath, Accountant
Sakura O'Brien, Receptionist/Secretary

Curatorial Department
Sheri Castelnuovo, Curator of Education
Marilyn Sohi, Registrar
Lori Dumm, Education Assistant
Doug Fath, Preparator
Lisa Lardner, Assistant Registrar
Janet Laube, Education Associate
Angela Webster, Photographer

Development
Ellen Efsic, Director of Development and
Community Relations
Barbara Banks, Director of Volunteer Services
David Lantz, Publicist
Betty Merten, Bulk Mail Specialist
Karen Weber, Art Fair on the Square Coordinator

Gallery Shop
Leslie Genszler, Gallery Shop Manager
Jennifer Stofflet, Gallery Shop Assistant Manager
Cristy Buss, Gallery Shop Assistant
Sloane Gillam, Gallery Shop Assistant
Stephanie Kliebenstein, Gallery Shop Assistant
Amanda Lee, Gallery Shop Assistant
Rebecca Lehnen, Gallery Shop Assistant
Gretchen Wagner, Gallery Shop Assistant
Amanda Zdrale, Gallery Shop Assistant

Gallery Operations
James Kramer, Gallery Operations Manager
Eric Lind, Gallery Operations Assistant
Matt Cole, Security Guard
Thea Crum, Security Guard
Christopher Frisby, Security Guard
Kristin Green, Security Guard
Ed Kreitzman, Security Guard
Ann-Marie Nelson, Security Guard
Joni Offerman, Security Guard
Kenneth Oppriecht, Security Guard
Laura Pescatore, Security Guard
Cassie Riger, Security Guard

Technical Services
Mark Verstegen, Technical Services Supervisor
Gayle Cole, Technical Services Assistant
Todd Berenz, Technical Services Assistant

following page:
Mother's Purse (detail), 1997

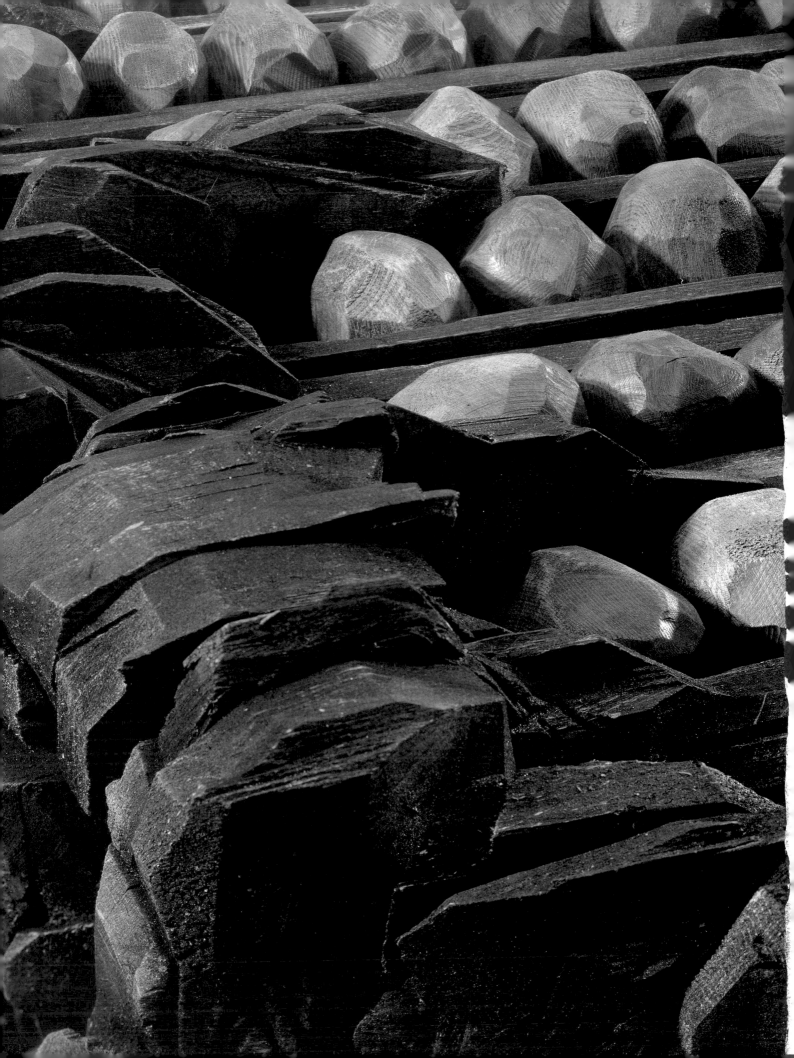